PHOTOGRAPHER'S GUIDE TO
Shooting Model
and Actor Portfolios

Photographs by Alan Lowy & C.J. Elfont
Text by Edna A. Elfont

AMHERST MEDIA, INC. ■ BUFFALO, NEW YORK

Published by:
Amherst Media, Inc.
P.O. Box 586
Amherst, NY 14226
Fax: (716) 874-4508

Publisher: Craig Alesse
Senior Editor / Project Manager: Michelle Perkins
Senior Editor: Frances Hagen Dumenci
Assistant Editor: Matthew A. Kreib
All photographs copyright © by: Alan Lowy & C.J Elfont

ISBN: 1-58428-005-0
Library of Congress Card Catalog Number: 99-72175

Notice of disclaimer: The information and suggestions provided in this book are based on the experiences and opinions of the author. The author and publisher will not be responsible or liable for the use or misuse of the information in this book.

Printed in the United States of America
10 9 8 7 6 5 4 3 2 1

Table of Contents

Introduction . **5**

CHAPTER ONE
Initial Contact & Pre-shoot Discussion **7**

CHAPTER TWO
The Contract . **20**

CHAPTER THREE
Preparation for the Shoot **30**

CHAPTER FOUR
Shooting Day. **40**

CHAPTER FIVE
**Processing Film, Shot Selection, Contact Sheet
Presentation & Final Image Selection** **70**

CHAPTER SIX
**Design, Printing, Packaging & Delivery of the
Finished Portfolio** . **92**

Index . **120**

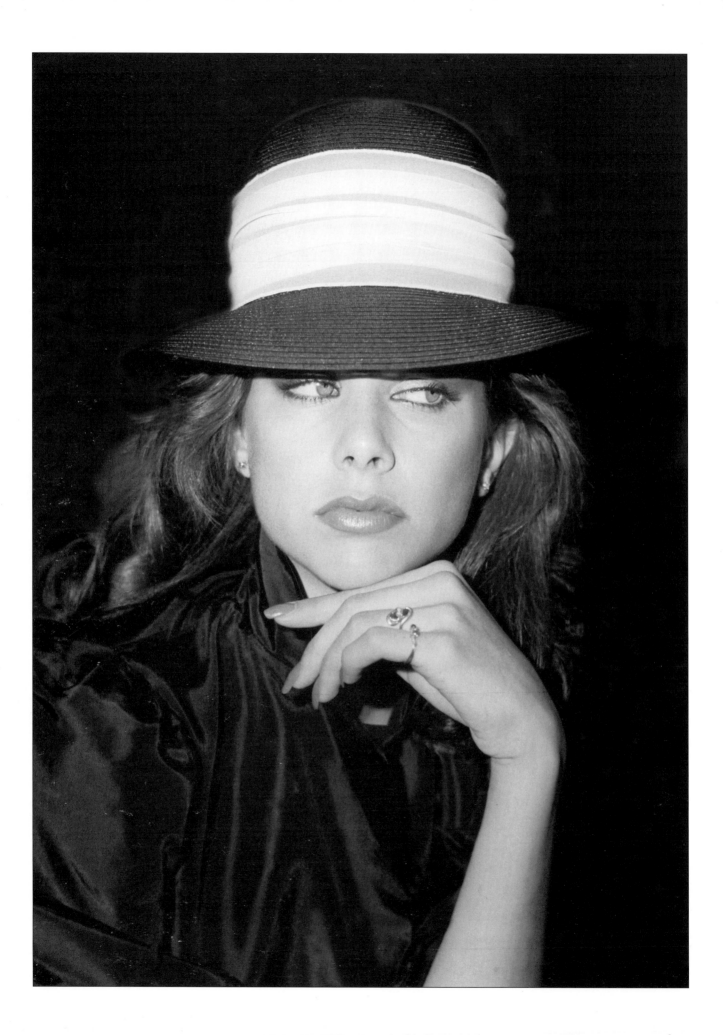

Introduction

"A photographer must first determine the model's and agency's goals for the portfolio..."

There is more to successfully shooting and producing a model's portfolio than taking good photographs of people. It requires a combination of artistic talent, technical knowledge, business and communication skills, basic psychology, and imagination.

A photographer must first determine the model's and agency's goals for the portfolio, then sell his or her specific approach based on those goals, draw up a formal contract, prepare in advance for the shooting, and have a well thought out plan for the day of the shoot that allows room for flexibility. After a successful shoot, the photographer must go on to select images for presentation to the model and their agents, design the layout, supervise or do the printing, and package and deliver the final product.

The photographer is the director, producer, and publisher of the finished portfolio. Nevertheless, you should understand and impress upon your model that the portfolio's successful completion must be the result of a cooperative effort between you. When the effort is cooperative, the model becomes an active participant in the creative process and he or she is more likely to be happy with the portfolio. Although this collaboration is important, the end product is primarily due to the photographer's personal vision and creativity. Therefore, you must maintain control of the collaborative effort.

It is important that a professional relationship be established between you and your client at the beginning of business negotiations. This professional relationship should be maintained throughout your business association. You should avoid making any suggestions of intimacy and thwart any initiated by the model. Any relationship that exceeds the boundaries of business can not only damage your reputation, it can lead to litigation. A good professional relationship will yield mutual respect which is an important factor in building a good reputation and in generating repeat business and referrals.

To shoot a good portfolio, you must identify the model's goals and create a finished product that will effectively assist the model in reaching those goals. A truly successful model portfolio photographer is one whose finished product also reflects his or her personal vision and talents.

For this image, framing the face with fur creates a soft look.

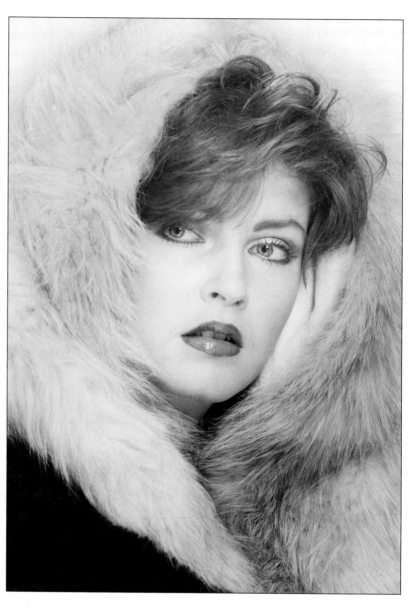

Initial Contact & Pre-Shoot Discussion

"Your first goal is to attract a client."

Your first goal is to attract a client. Most portfolio photographers find it advantageous to advertise even if they have referrals from friends and previous clients. Besides newspaper advertising, you may wish to post fliers on public service bulletin boards and distribute them at modeling and talent agencies, beauty salons, specialty boutiques, or health and fitness clubs. Only your imagination and budget limit the types of advertising you pursue.

Although a prospective client is most likely to make initial contact with you by telephone, numerous other scenarios are possible. An initial contact may result from an accidental meeting at a party, in a grocery store, or in line at a movie or restaurant. For this reason, you should always carry business cards.

Your first objective should be to arrange a pre-shoot discussion. During this discussion you will show your portfolios and explain, in detail, what you can do for the potential client. If you have no official business location apart from your home, you might suggest meeting in a public place such as a restaurant, mall, or community center. Avoid urging a model to meet you at a location in which they might feel uneasy. For everyone's protection and peace of mind, regardless of the meeting's location, suggest they consider bringing along a friend or relative.

During the initial contact, determine if the prospective client is a minor. If this is the case, a parent or guardian must be present at all meetings and shoots. Tell any young model that they must present proof of age at the pre-shoot discussion. Before accepting a deposit from or signing a contract with such a client, photocopy their driver's license or birth certificate for your files. If you do not have

This fashion shot features a business look. It's important for you, as the photographer, to understand the goals of your client and produce a portfolio that meets those goals.

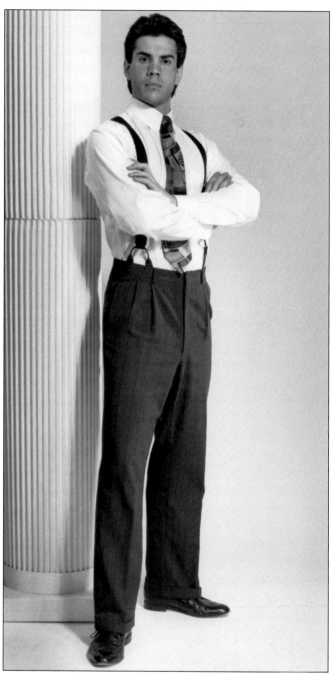

access to a photocopy machine, ask the prospective client to bring the original document and a photocopy of it with them. This may protect you from legal problems arising even years later.

Another objective at your initial contact with the potential client is to explain your particular approach to portfolio photography and how that approach may offer them something they may not find elsewhere. Include a description of your past work, emphasizing any that carries name recognition. For instance, be sure to mention any clients who are well-known models, well-known agencies

This image shows the client's more casual fashion side. By including both images in the portfolio (see photo on opposite page), you highlight the client's versatility.

for which you have worked, or magazines in which your work has appeared. If you are a newcomer to portfolio photography and have no body of work, you will have to be especially inventive and persuasive to convert a casual inquiry into a contract discussion.

Although the model may have many specific questions, answer them as briefly as possible during the initial contact. Leave full explanations for the pre-shoot discussion or you may spend a great deal of time on a less than serious inquiry. If the prospective client requests pricing information, explain that actual costs depend upon

If the client is unsure about the specific goals of the portfolio, have them speak to their advisors, agency or other models.

the type and complexity of the portfolio and that you will be better able to determine this at the conclusion of a pre-shoot discussion. If the model insists on knowing costs, quote a range of prices from your lowest to your highest.

The final objective of your initial conversation with the potential client should be to find out if they have clearly defined the goals they expect the portfolio to meet. It is not important to have the client describe those goals until the pre-shoot discussion. If however, they are unsure about the markets to which they want to appeal or what part a portfolio will play in the process, suggest they talk to their advisors, agency, or to other successful models to help them formulate these goals. This will help make your pre-shoot discussion more productive. You might also suggest that they bring you images from magazines or newspapers (tear sheets) of a style they would like to see in their portfolio.

For those photographers with a place of business, the initial client contact may result from a walk-in. If the potential client brings tear sheets and already has ideas about what they want included in their

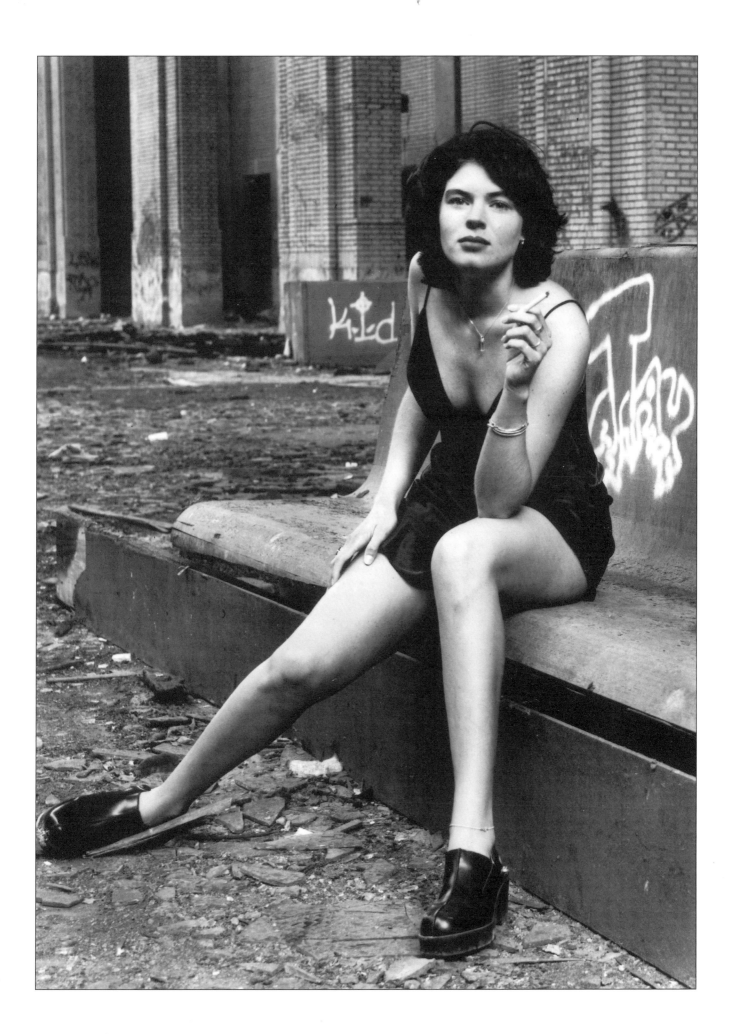

Many photographers supplement their work with a binder of magazine tear sheets illustrating current trends in model photography they would like the opportunity to use. This is not, however, a substitute for an original portfolio. If you just started a photographic model portfolio business and have few or no images of models, you must build a body of work. One method to accomplish this is to offer free prints to a friend, relative, or acquaintance in exchange for their permission to use those prints in your portfolio. Select a dozen or more of the best images and make 8x10 inch prints of each. For a professional presentation, buy a zippered 8x11 portfolio case from any office supply store and insert the prints into the sleeves. Expand your portfolio as often and quickly as possible. Periodically, refresh it with new images removing those that appear dated.

An important part of the pre-shoot discussion is to determine the goals your prospective client or their agency has for the portfolio. The job market(s) in which the model wants to work (e.g., fashion, trade show, entertainment industry, or product industry) often dictate the goals. Individuals interested in the entertainment business

"Expand your portfolio as often and quickly as possible."

This image features the use of a highly textured, natural background to complement an on-location fashion shot. The scarves are one of many types of accessories we keep on hand.

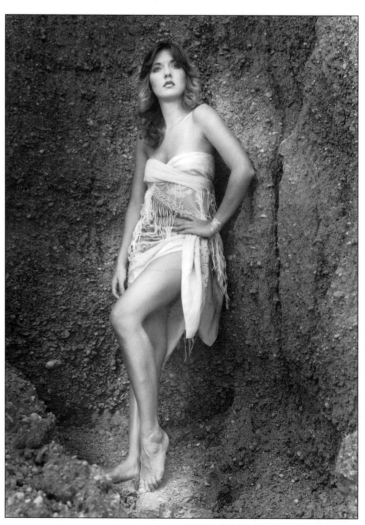

need a portfolio showing their ability to portray a full range of emotions while those wanting to be fashion models need a stylized look that fits in with current fashion trends.

A portfolio for a parts model (one who models only legs, hands, hair, etc.) should look quite different from one done for a model hoping to break into New York's high fashion runway scene. Eventually, every photographer is faced with a potential client whose goals are extremely unrealistic. You may attempt to persuade such a client to alter their goals or you may decide you cannot work with such an individual. The wisdom of either of these choices however, is too dependent on the personalities of the individuals involved for us to generalize here.

Once you have determined your potential client's goals, sell your specific approach by describing how you envision the finished portfolio. If possible, support your ideas by showing examples from your portfolios. Although you want your prospective client to think you are wonderful, avoid implying that they will find their dream job based solely upon the portfolio you create.

When your potential client is no longer potential, you must discuss a number of details with them before signing a contract. As you go over these details, make precise notes so you can later verify them with your client and use them to calculate the final cost of the portfolio. Begin by describing your standard portfolio package(s), what they include, and their cost. Then go on to describe options you offer such as on-location shooting (out of the studio) and use of support personnel (e.g., make-up or clothing stylists, additional models, or a model assistant). Consider specific requests the model may make that go beyond the scope of your normal packages. It is important that you explain the advantages of, and additional cost for, each add-on.

If requested, it is acceptable to allow a third person of the client's choosing (a relative, friend, or agency representative) to be present at the shoot. This person can assist the model with clothing changes or be present just for the client's moral support. If you allow such a person to be present, make it clear that they should be all but invisible and not interfere with the shoot.

The next topic to discuss concerns what "looks" to include in the portfolio. You must then decide what wardrobe, props, accessories, make-up, and hairstyles are necessary to achieve them. Detail those combinations of items you know are most likely to produce successful images. For instance, if a client is a vocalist or musician, suggest they bring a musical instrument or a prop like a microphone. If the model's interest is in doing business and trade shows, suggest appropriate business attire. Props might include a briefcase,

Quick Tips

During the pre-shoot discussion, describe your standard portfolio packages, what they include and their cost.

glasses, clipboard, or lap-top computer. Should the client desire to enter the fashion industry, you may want to photograph them in a variety of clothing styles such as casual sportswear, evening clothes, work-out attire, swim wear, or blue jeans and shirt. Uniforms (i.e., military, mechanic's, medical, or athletic team) may be desirable if available and appropriate to the client's specific goals.

Here's an example of a formal fashion shot. The photo on the opposite page shows a more casual out-doorsy look, using a ladder as a prop. These photos effectively demonstrate the model's diversity.

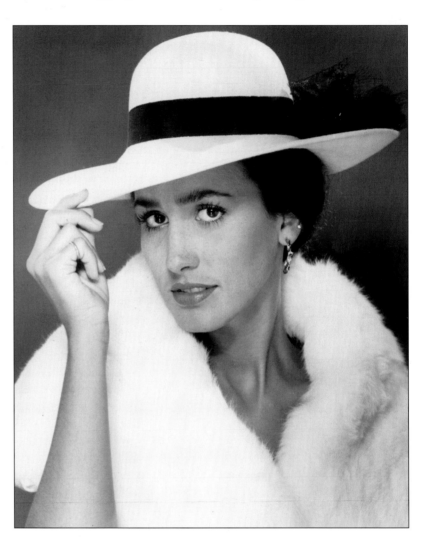

For female clients interested in beauty or glamour modeling, suggest form fitting or sensual looking clothes such as a swimsuit, low cut tops, or lingerie. Suggest those "looks" you think will emphasize the model's outstanding features and the clothes or props that will draw attention to them.

If a female model has nicely shaped legs, you might suggest she bring a mini skirt or an evening gown with a slit long enough to show off this feature. For performers, pick outfits and props that will best compliment the acting style in which their talents lay. When working with a youngster or adolescent, suggest clothing

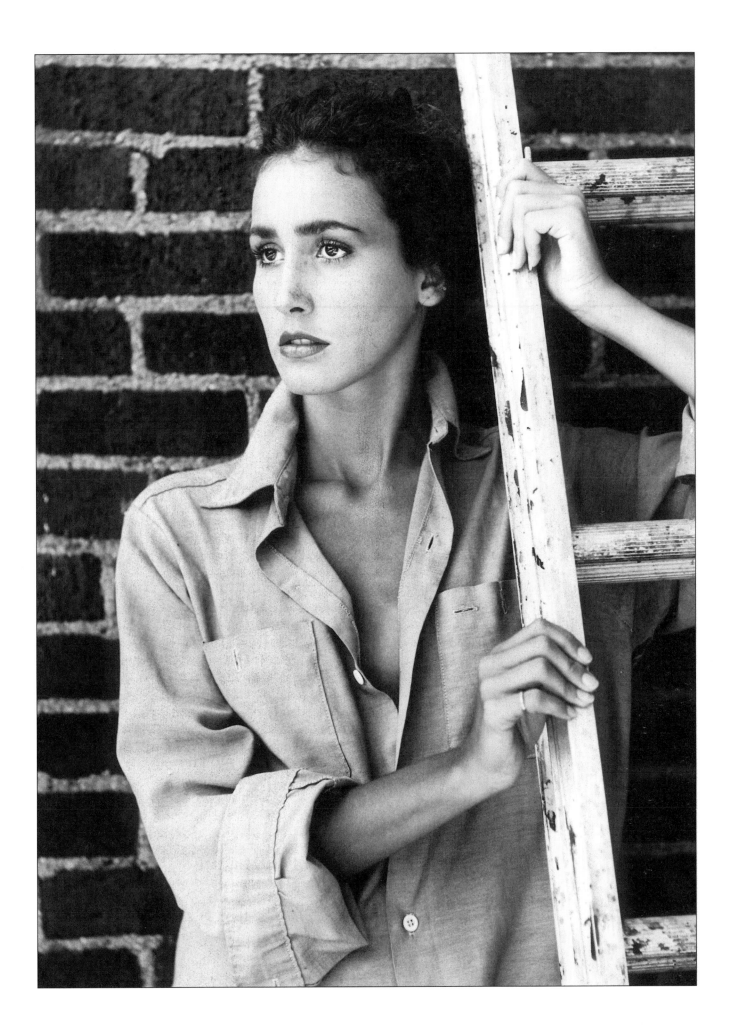

styles and props to create images that make the child look not only their actual age, but 2-3 years older and younger.

Do not press a client to be photographed in outfits that make them feel uncomfortable. Their discomfort will often show in the final images and neither of you will be happy with the results. If, on the other hand, the model suggests props or outfits you know will not work, try to discourage them. However, if your client insists on something you feel certain will produce a less than pleasing result, document the item on which you disagree in the contract. A statement such as, "Image with wide-brimmed hat included at client's insistence," might protect you from having a client, who does not like the result, insist later that they never asked for such a pose. If possible, shoot their requested pose and then create a variation you think may be more successful. Later, present both to the client. If your ideas consistently produce superior images, your client will be more likely to trust your judgment in future sessions.

Over time, accumulate props you find particularly useful and that may be hard to locate on demand. You will find items like hats, scarves, feather boas, uniforms, an assortment of costume jewelry, period clothing, and even rattan furniture in flea markets, garage sales or re-sale shops. Let your client know what items you have that you plan to use. If you have a Roaring Twenties flapper's outfit you think will be perfect, tell them so they have time to think over whether or not they share your opinion. Remember, if your client is enthusiastic, the images you will capture will show it and the portfolio is more likely to make both of you happy.

If your client does not request an on-location shoot and you feel it would be to their benefit to be photographed someplace other than the studio, describe to them the pluses, minuses, and costs of on-location shooting. Keep a list of sites that you know are accessible to commercial photographers and update it whenever possible. Having pictures of the sites to show your client will enable them to make a selection more easily. Choose sites that have interesting or unusual features such as winding staircases, rooms with period furniture, doorways with unusual trim or textures, or fountains to name just a few.

Once all items have been discussed and resolved, your client will want to set a date for the shoot. There are two things to which you should attend before pulling out your calendar. Have the client sign a contract (See Chapter 2) and collect a deposit. There may be items to which you both agreed during this pre-shoot discussion that go beyond your basic contract. Your contract should have a large blank area in which you can print or type these items. Read the contract aloud with your client, clarifying any items in question before either of you sign it.

Quick Tips

Keep a list and photos of on-location sites that you can use for photo shoots.

"Two copies of the contract should be signed."

Two copies of the contract should be signed so each of you has a copy with original signatures in case any questions arise later. If possible, have your client sign the contract immediately after the pre-shoot discussion so the items discussed are still fresh in their mind. You will need to find a third person however, to act as the witness. Some clients may prefer to take the contract home so they can discuss it with parents or advisors before signing and paying a deposit. Before you release it, make sure you have a copy. If you agree to allow your client to mail the signed and witnessed contract to you, they must do it in duplicate so that you can both end up with original signatures on your copy. You may have to sign one copy and mail it back to your client unless they agree to pick it up on the day of the shoot. Some photographers require that contracts, signed in their absence, be notarized or bank-guaranteed. Consider requiring this if the client is a minor and the signature must be that of a parent or guardian.

The amount of the initial deposit varies considerably from photographer to photographer, but is rarely less than one-forth or more than one-half of the final amount. If the client is unable to pay the deposit, tell them you will set up a preliminary shoot date. Assure them that you will confirm the date and time upon receipt of the deposit.

Finally the contract is signed and the deposit collected. You are ready to set the date and time for the shoot. Be sure to draw your client's attention to any clauses in the contract that deal with monetary penalties if they do not appear for, cancel, or delay the shoot with less notice than required. There is an old saying that the job isn't finished until the paper work is done. In this case, the job doesn't start until the paperwork is done.

The Contract

"A contract is the most significant piece of paperwork you can generate."

If you are like many of your colleagues, doing paperwork is low on your list of priorities. You probably have a model release, but there is at least one other document you should have for every client — a contract. A contract is the most significant piece of paperwork you can generate. Frequently, photographers simply copy one from someone else, put in their name and address, and give it very little additional thought. Some photographers choose to work with no contract. We feel this is a bit like walking a high wire without a safety net and we do not recommend it.

Having a contract helps to avoid misunderstandings between you and your client, misunderstandings that might lead to litigation. Although no contract can keep a client from suing you, having a contract considerably strengthens your position should you ever be faced with a legal dispute.

Carefully consider what you want your contract to contain and the implications of including or excluding any specific detail. When you choose to include some item, you commit yourself to whatever is in print. When you exclude an item, you have more flexibility, but you risk a misunderstanding.

Contracts and what they include vary from photographer to photographer. If you have friends in the field, you may want to look at the contracts they use before creating your own. Before you finalize its form, ask an attorney to review any contract you decide to use.

There are several main areas of concern you may wish to detail in your contract: the services to be provided by the photographer, the fees (which requires you determine your costs and keep them current), the payment terms, waivers of liability and disclaimers, and the granting of rights to use the images.

The head shot on the opposite page emphasizes the model's positive features as a jewelry model.

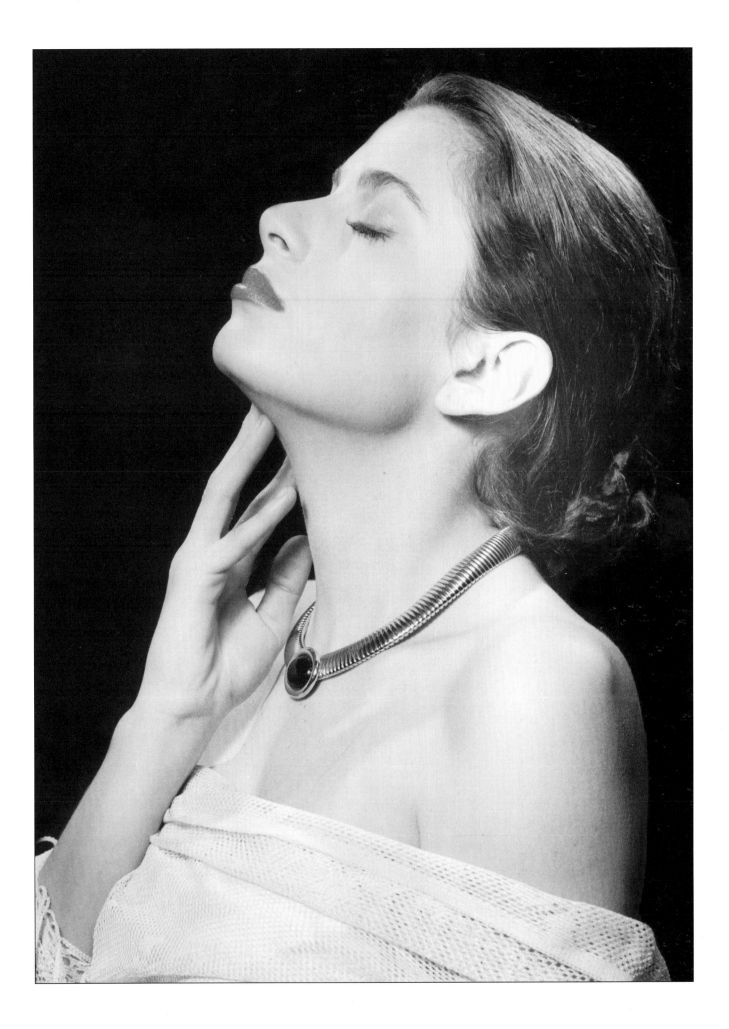

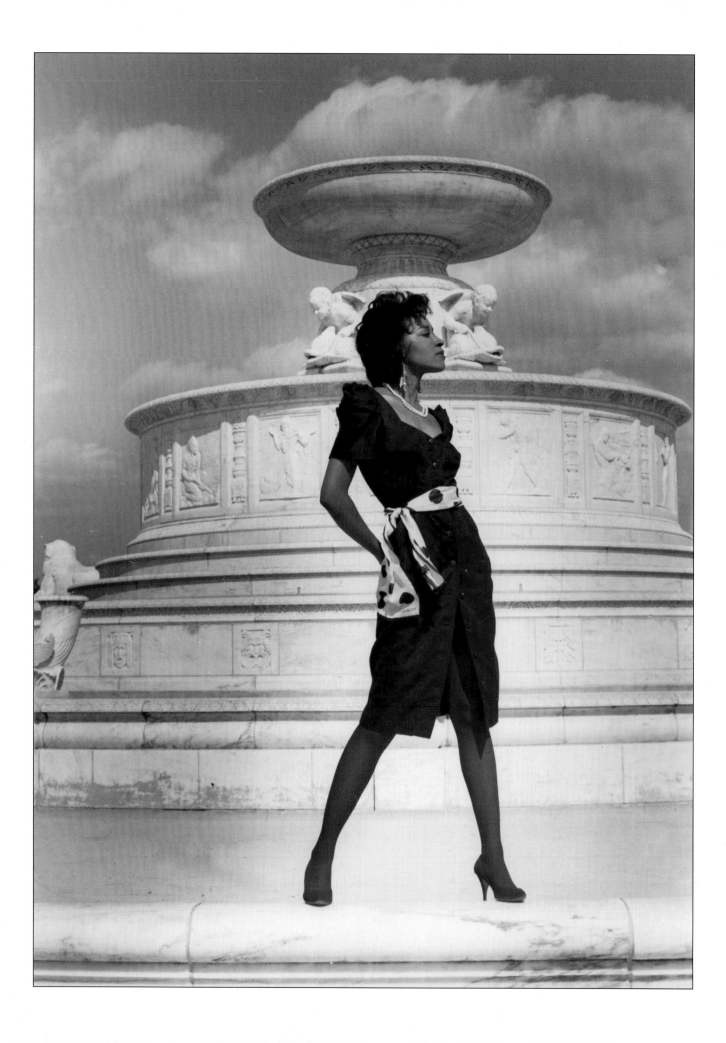

Services to be provided by the photographer might include:

1. The projected turnaround times for the different phases of the work. This should include the day, date, and time of the shoot and its projected duration. You want your client to know how long the shoot will last. This acts to control models who would live in the changing room at your expense if allowed. Detail contingency plans for rescheduling the shoot, should that be necessary, and list a range of dates by which you will deliver the proofs and the final portfolio.

2. How many rolls of each type of film you will shoot (for example, 4 rolls of 35mm color and 2 rolls of 2¼ black & white). Include a statement that if you shoot more rolls at the client's request, your normal fee per roll will apply.

3. What adjunct personnel you will hire. For instance, if you require the use of personnel such as a make-up artist, this should be so stated.

4. The number and size of the prints and the size of the final portfolio.

5. If there will be an on-location shoot, specify particular locations (a studio, a park, a specific building, etc.), if desired.

6. Additional services such as a model's composite card or special film processing.

7. Who will be responsible for providing clothing and/or costumes including accessories. If you choose not to list in the contract any items you have agreed to provide, make a note of these items elsewhere so you can review them when you are preparing for the shoot. For most shoots, models are responsible for providing their clothing and accessories. The photographer often keeps on hand accessories like earrings, necklaces, hats, eyeglass frames, and props such as books, chairs, and columns.

Instruct your client to bring appropriate accessories and props such as exercise weights, a tennis racket, golf clubs, scarves, unique jewelry, hair clips, shoes, or beach towels to complement their costumes. Models are usually responsible for bringing whatever make-up they require unless you have hired a make-up artist. If this is the case, make sure they know if your client has any make-up allergies.

The photo on the opposite page is a high fashion image that was shot on-location. Note the symmetry of the background to compliment the model and her pose.

A beaded scarf was used to dramatize this model's profile.

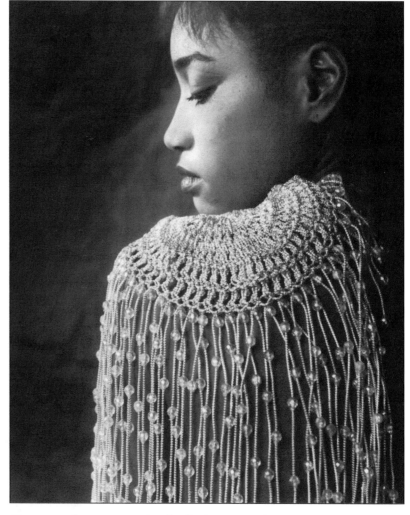

You may choose to individually list some fees in the contract and express others as packages. Most photographers offer packages with optional add-ons. Add-ons frequently listed in contracts include:

1. Price per extra roll shot. You should list this item separately even if a package is being offered. This means that if, during the shoot, the client requests additional rolls be shot, they are already fully aware of the cost.

2. Additional personnel such as a hair stylist, make-up artist, or manicurist.

3. Rush jobs requiring delivery of the final product in a shorter time than that for which you would normally contract.

4. Composite cards. Composites are often made using images from the model's portfolio, but usually for an additional cost. A composite card is typically a single sheet with 2-5 pictures of the model on one or both

sides and data about the model on the bottom. Composite cards range in size from 5x8 to 8x10 and are occasionally bi-folds. Many models use the composite card as a preliminary contact hoping it will interest their prospective clients enough so they will want to see a full portfolio. Also, after viewing a portfolio, a client may request that the model leave a composite card for later reference.

5. Portfolio cases. These can take many forms and are discussed in some detail in Chapter 6.

One photographer's add-ons are another photographer's essentials. For example, some packages automatically include the services of a make-up artist while others offer this service as an additional cost. In the contract, you should document the items included in the package your client has chosen. Package types have an unending variety, but some of the more popular are:

This b&w swimwear image was shot on-location. The interesting overhead view was achieved by shooting from a ladder.

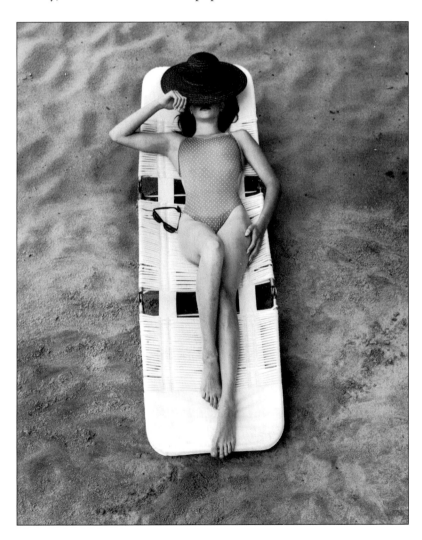

1. Price per roll shot. This package specifies the type of film you will use and usually includes the contact sheets, a specified number of prints of a specified size, and a portfolio book of specified type. It may also include a lower and upper limit for the number of rolls.

2. Flat fee. This fee is an all-inclusive one. It includes how much time you will spend, how many rolls you will shoot, and what will be included in the finished product.

3. Day rate. This is somewhat less popular than those listed above. It is based on the amount of time the photographer spends doing the shoot. The client is responsible for all film, processing, and other costs to which most photographers add a mark-up.

"It is laborious, but important to determine your costs..."

It is laborious, but important to determine your costs, put a value on your time, and decide what mark-up the traffic will bear on materials and processing. Many photographers do not put these figures on paper and, therefore, end up arbitrarily pricing their packages and extras. Some of the items for which we make sure we keep updated pricing are:

1. Time. We price studio time differently from on-location time only if the same job will take more time on-location than it would in the studio. We build in a price for travel time if we will be spending more than an hour getting to a location. You have to decide what fee you must receive to stay in business and make the profit to which you feel entitled.

2. Film, processing and contact prints.

3. Rental fees (if any).

4. Auxiliary personnel (if any).

5. Final prints. A portfolio contains approximately 12-20 images. Print size is usually 8x10 or 11x14 though some New York agencies prefer 16x20.

6. Portfolio cases (leather, zippered, clamshell, etc.) or other special packaging.

7. Special processing or rush jobs.

The photo on the opposite page shows a character shot for an actor's portfolio. In this image, the model has an Eastern European look.

One portion of your contract should detail payment terms and the payment schedule. We know of some photographers who ask for no deposit up front and receive their payment in one lump sum at the end of the job. Others collect 50 percent when the contract is

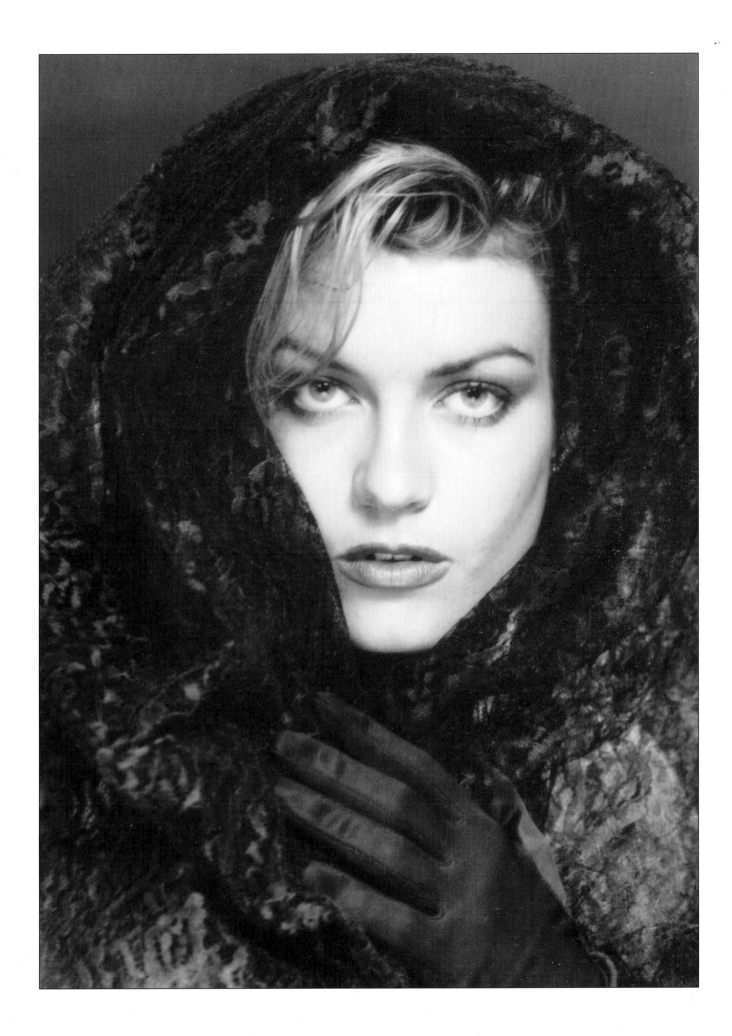

signed and the balance at the end of the shooting session. Some collect the entire amount at the beginning of the shoot. There are numerous variations possible, but we suggest the least you do is collect one-third at the contract signing, one-third at the end of the shoot, and the final third upon delivery of the contact sheets. This eliminates your paying for the finished product with your funds and trying to collect after the client has possession of the portfolio. Your contract should include any monetary penalties you choose to impose if a client does not show up for the shoot. Consider including a monetary penalty if the client fails to give you less than 24 hours notice that they want to reschedule the shoot.

Your contract should include a waiver of liability (otherwise referred to as an indemnification agreement) and some disclaimers. An attorney should assist you in writing your waiver or should review any waiver you copy since the wording may need changing depending on state laws and court decisions. Sample agreements are available from photography societies such as the American Society of Media Photographers, Inc. (ASMP). Besides the waiver of liability, consider including several other disclaimers.

1. It is prudent to include a statement that you have the right to alter the details of the shoot if the original plans become impossible to fulfill (due to no fault of yours). For example, you may have included in the contract that you will shoot at a specific location. If, however, the weather does not cooperate on the day of the shoot or some new site restrictions require a fee or prohibit its use altogether, unless you have a disclaimer, you may have to amend the contract. You may think you can avoid this potential problem by simply not mentioning the location in the contract. If, however, you exclude this information and are unable to shoot at the location the client requested, you risk an argument about payment that might end up in court. Without documentation, you may possibly lose such an argument.

2. State that you are not responsible for either a refund of the deposit or a re-shoot if the model does not like the final photographs. You may want to include a statement that if you cannot deliver the images (per the contractual agreement) due either to an error of your own or a processing lab's error, you are liable only for a refund of the client's deposit. Some photographers, however, offer a re-shoot under these circumstances.

3. Consider including a statement that the completion of the portfolio in no way guarantees the client will find employment.

Quick Tips

Waiver of liability samples are available through the American Society of Media Photographers, Inc. (ASMP).

Finally, the contract must include a statement that details who has rights to the negatives and prints and how each party may use them. This section of the contract includes model release statements. Samples of such are available from numerous sources including the ASMP as previously mentioned and the National Press Photographers Association (NPPA). Both of these organizations have Internet home pages. We believe that photographers should keep the rights to their negatives and images for future commercial and personal use. The client should buy only the right to use the photographs. Occasionally, a photographer will agree to sell both the negatives and the rights to the images, but hopefully not before they carefully consider the long-term implications of such a decision.

Before we leave the subject of paperwork, remember to provide duplicates of all legal documents, including releases, to your client. You should also provide them with receipts for all payments. When you are confident the paperwork is out of the way, preparing for the shoot is your next concern.

Preparation for the Shoot

"It is important that you prepare for each shoot."

It is important that you prepare for each shoot. If you prepare, your shoot will usually proceed efficiently. Consider the risk you take if you do not prepare for an event for which there will be no second chance or the repetition of which will cost you money, time, and loss of reputation. Each model shoot is such an event. Perhaps the most compelling argument for preparation is that it is hard to concentrate on the creative aspects of photography when you must also deal with organizational and technical details. Adequate preparation allows you to deal with these details before you pick up your camera.

Since the success of the final portfolio is the result of a cooperative effort between model and photographer, both need to do their part to prepare. Although the bulk of the preparation is, of course, the photographer's responsibility, the model has homework to do as well. Most models are expected to bring their clothes and/or costumes. Tell your client how many costume changes to bring. This depends on the type of market to which your client is appealing, the location of the shoot, and the time you have committed to it. Caution your client to select only those outfits that will be flattering as well as appeal to those agents they plan to approach. Your client must also have some feeling for what the camera will see. Remind them to carefully consider what accessories to wear with each clothing change. If your client appears to need guidance to properly select the garments to wear, suggest they consult with a stylist if you do not wish to undertake this role.

Your client should come to the shoot well rested and appropriately groomed. Some models prefer to visit hair and make-up professionals prior to the shoot. If that is not the case and there will be no

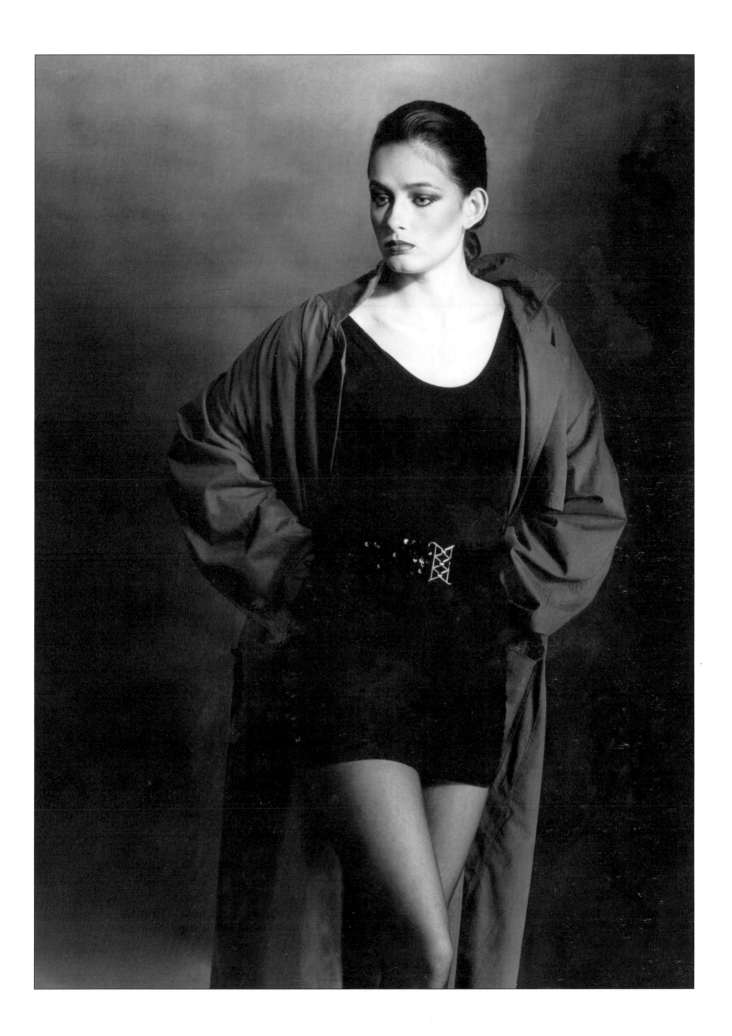

hair stylist or make-up artist on the set, your client should come prepared to begin the shoot with the simplest looks. Additionally, in the absence of a hair stylist or make-up artist, the model must bring sufficient supplies to change their hair and/or make-up to achieve whatever stylized looks the two of you have chosen. Your client must be able to create these looks without assistance and in a limited amount of time. Advise them to practice well before the shooting day.

A model may often be responsible for finding and bringing props that will allow them to portray one or more specific character types. They may also have agreed to make the arrangements to secure permits for the use of a specific location. Emphasize to your client that without their active participation in the preparation, the shoot cannot be successful. The photographer's preparation may include any or all the tasks that follow.

As in these photos (opposite page and right), certain props or clothing help clients portray specific character types.

Head shots should come first during a session while make-up and hair are fresh.

"We suggest that you start the session with head shots…"

We suggest that you start the session with head shots because close-ups are best taken while the model's make-up and hairstyle are fresh. Follow these with three-quarter and full-body shots having the model wear the simplest outfits first. Work up to the more elaborate ones requiring the strongest make-up.

The very last photographs you take should be those for which your client must do something to their appearance that is not easily reversible such as wet their hair for a bathing suit shot or apply body lotion for a shot in exercise garb.

We find it useful to sequentially shoot specialty shots such as legs, hands, or nails. If you group shots like these together, they will lie next to one another when you view the film on a light box or when printed on a single proof sheet. It is then much easier to select the best of them.

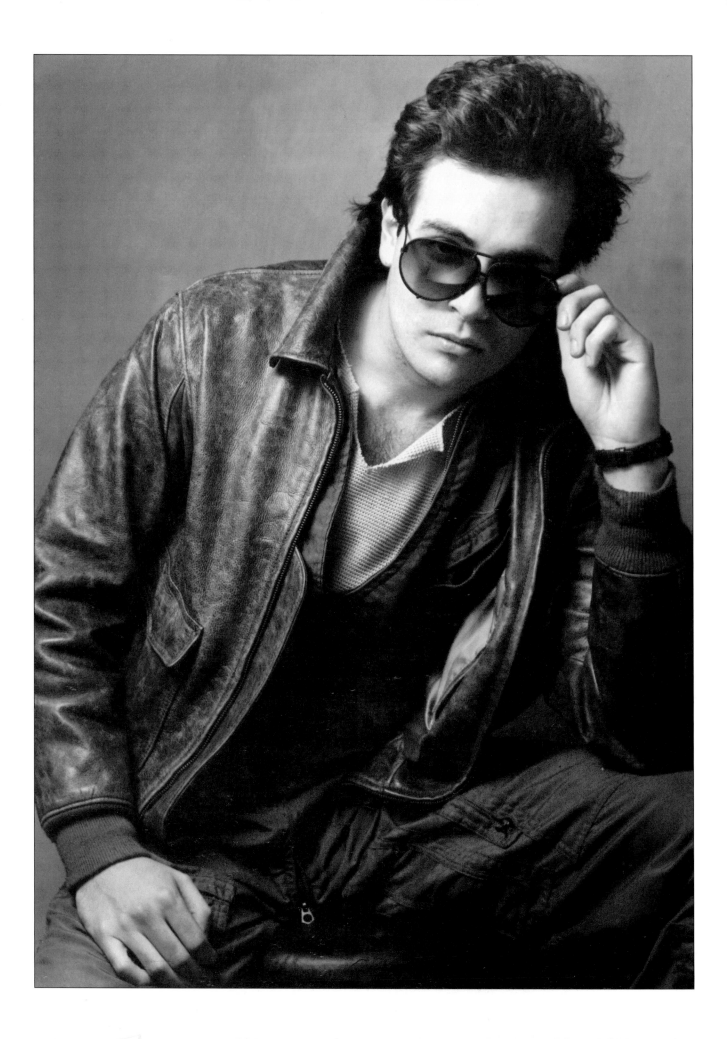

A checklist is a good way to ensure that you have all the necessary equipment needed for a photo shoot.

Check that all the equipment and accessories necessary for your shoot are on hand and are functioning properly.

Many photographers use checklists to ensure they have everything they will need, particularly when shooting on-location. Check that each item functions properly and is clean. You will not look very professional if your flash unit refuses to function or you cannot extend the legs of your tripod because they are frozen with sand.

If you are using 35mm format, we recommend that you have at least two camera bodies. Not only does this provide a back-up body, but you can load one with B&W and the other with color film. Lenses to consider using for your shoots are a 28-80mm and a 70-210mm lens or any other lenses using some combination of these focal lengths. Medium format camera users should consider using a 50 or 60 mm wide-angle lens, a normal 80mm lens, and a 150 or 180mm focal length telephoto lens. Most medium format cameras have interchangeable backs so switching from one film type to another is easier than it is for 35mm users.

Other essentials to have on hand include sturdy tripods that breakdown and set up quickly and easily, cable releases, an assortment of filters such as soft focus, polarizing, or other special effect filters, lens shades, electronic flashes, soft boxes and/or umbrellas, reflectors, light stands, slave units, a combination flash and ambient light meter, a large assortment of batteries, and an adjustable posing stool. This list is not all-inclusive, but it gives you a good starting point.

For those photographers using digital formats, equipment checking should extend to downloading a few test images to check both the camera and its software. As this technology continues to evolve, although the items you may need to have on hand will change, the need to pretest them will not.

Pick the films that will work best for you under the conditions of the shoot as you have planned it. Do not forget to take both B&W and color film if the client has contracted for both. (Digital format users are spared this area of concern.) Long before signing your first model portfolio contract, you should experiment with a variety of films and film speeds and know which ones work best in your hands. Determine the one or two films and film speeds that give you the kind of results you want and stay with them. Do not test a new film or shooting technique on a paying client!

Use fresh film (un-expired), preferably from the same batch. Before using a new batch of film, we suggest shooting one or two test rolls to check for film speed consistency and to avoid any surprises due to a bad batch. Use well known, brand name, USA-warranted, professional films to ensure consistency from batch

Use of props as simple as sunglasses and a leather jacket can help you achieve a specific look.

to batch. If you should decide to use gray market film from one of the many sources that sell it, you should be aware the manufacturer will not guarantee the film.

Since most photographers buy their film in large quantities and refrigerate or freeze it, we and the manufacturers recommend the film be brought to room temperature well before the shoot.

Decide if you will need specific props and/or backgrounds.
The variety of items that you can use as studio props is endless. Some of the more common ones include venetian blinds, columns and pedestals, chairs (antique, wicker, or beach), books, wine glasses, silk flowers, eye glass frames (with glass removed), a painted ladder, and sporting goods (baseball bat, golf clubs, bicycle, football, or tennis racquet). Make sure your selection is appropriate if some of your clients are children. Garage sales and flea markets are a great source of props.

If you are doing a studio shoot, be prepared to set up at least two background changes so the images in the final portfolio will not look repetitious. If your studio is large enough, you may be able to set up two backgrounds at once. If however, you must take one down to set the next up, make sure you practice this maneuver before shooting day. You must know how to handle the background material without damaging it. A damaged background can ruin an otherwise great model shoot.

We suggest using nine-foot wide, seamless, paper or muslin backgrounds because standard background stands and cross-poles are designed to accommodate this size. Hand painted and photographic backgrounds are available from a number of sources although the colors most often used are white, black, or gray. You might like to have a textured background for variety.

Backgrounds and props are available from many large camera shops and mail order photographic specialty dealers. We suggest you check *Shutterbug*, *Photo District News*, and other photographic magazines for sources. Photographic dealer shows often have at least one dealer who sells backgrounds. For those of you who have access to it, the Internet can be a valuable source of manufacturers and suppliers.

Select the specific location and secure it for the day of the shoot.
When you select the location at which you will shoot, keep in mind that the model must be the center of attention. The setting may add a mood to the shot or enhance its overall eye appeal, but it must always remain of secondary interest.

You may have already selected a specific location and an alternative with your client. However, if you spoke with your client only in generalities, indicating the shoot will take place in a park or at a fountain, make sure you select specific sites well before the shoot. Try to have an alternative site in mind in case an unplanned event makes your first selection undesirable. For instance, if you had decided to use a downtown location that became inaccessible on the day of the shoot due to a fire, accident, or demonstration, you might know of a suburban site that could substitute. You do not want to have to reschedule.

You must obtain any necessary special location permits unless your client has accepted this responsibility. Such permits may be necessary to use certain private property, state and national parks, historic buildings, city property, and a host of others. Obtain permits well in advance. On the day of the shoot, post one copy in your car if parking is by permit only and carry another copy with you for the edification of any inquiring official. Do your best to find out if any events have been planned for the location. Neither you nor your client would be pleased to find a boy scout troop at the same secluded state park beach you wanted to use for bathing suit shots.

"Some photographers like to contact their client the day before the photo session."

Some photographers like to contact their client the day before the photo session. This allows you a chance to go over a quick checklist of things the client must bring with them the following day. It is also an opportunity for you to offer reassurance so the client will be more likely to arrive at the shoot relaxed. You should ask if they have any last minute concerns with which you can assist. You might also inquire if there have been any changes to your client's appearance (hair color or style changes, tattoos, abrasions, lacerations) which might cause you to modify some of the shots you had planned.

The manner and extent to which each photographer prepares for a model's portfolio shoot is as individual as is the photographer. The length of your task list is unimportant. What counts is that your preparation is sufficient to ensure that the shooting day goes as smoothly as possible.

CHAPTER FOUR

Shooting Day

"Be disciplined, but allow yourself enough freedom to be creative."

Today, you are the conductor and the client is the musician. You know the score, the tempo at which you want it played, and what kind of emotion you wish to evoke from your musician. Although the success of the performance is a joint effort between you and the musician, you must be in control. Be disciplined, but allow yourself enough freedom to be creative. You must also know when to demand discipline from your musician and when to allow creativity.

If you followed our suggestions in Chapter 3, all you will have left to do is be certain that all backups are in place and on-location equipment is packed or studio equipment is set up. Before your client's arrival, recheck that your camera is in sync with your electronic strobe units. This means that you set your camera's shutter speed no higher than that recommended by the manufacturer. Position your lights (strobes) and take readings with a flash meter so you know at what distances from the model to place your strobes for the various f-stops you prefer to use. Recheck these readings once the shoot begins because, as your model moves, you may have to reposition your lights.

When using natural light, we take frequent ambient light readings because ambient light can change rapidly with the time of day, cloud cover, etc. We like an exposure meter that can be used for both flash and ambient light readings. This eliminates the need for two separate meters when you are working with both natural and artificial light. (Dual-purpose flash/ambient light meters are available from a number of retailers.)

If possible, we suggest taking Polaroid test shots to check lighting and exposures. Polaroid films are now available with ISO ratings similar to those of standard roll films. Medium format and larger cameras with interchangeable backs and film holders lend themselves best to Polaroid testing because you can use Polaroid film

backs or holders. Users of 35mm cameras do not have this luxury and many of them choose to buy a separate Polaroid camera for this purpose.

When using a tripod, we recommend some form of quick release mechanism for removing the camera from the tripod. This eliminates down time when having to change camera bodies or when you want to hand-hold the camera. The more down time you have, the greater the chance you could lose a mood you worked hard to create.

While you are shooting, one of the most important things you can do is to keep your client at ease and participating in the creative process. If you are going on-location, consider traveling in the same vehicle with your client so this process can begin well before you pick up a camera. In the studio, we like to sit with our client for a few minutes after their arrival and share some small talk and possibly a non-alcoholic beverage (soft drink, coffee, tea or bottled water). Our experience has shown that this interlude often helps put the model at ease, particularly a novice.

After this introductory interlude, look at the outfits your client has brought. If possible, hang up the outfits as you discuss which of them you would like to use. Hanging them up allows you not only to view them better, but you can sort them in the sequence you wish to use them. Because a client may bring an excessively wrinkled outfit, you might consider keeping a small, portable clothes steamer on hand. Do not urge your client to use an outfit for which they show no enthusiasm. The more enthusiastic a model is about what they will be wearing, the better your chances are for a successful shoot.

If a make-up artist and/or hair stylist has been hired, we prefer they begin working with the model about an hour before the shoot. This allows you to check their results under the lighting conditions you will use and suggest changes if you feel they are necessary. Many photographers request these professionals stay for the duration of the shoot to restyle hair or change looks while some prefer they leave after the shoot has begun.

And finally the moment comes when you get to listen to the music photographers love to hear — the click of the shutter. As mentioned in Chapter 3, we prefer to start the shoot with head shots. Not only are the model's make-up and hairstyle freshest at the beginning of the shoot, but this an excellent time to work with your client to assist them in evoking the moods you may wish them to repeat later. Photographers use many methods to get their clients to perform in front of the camera. Vincent Versace, a much-sought-after West Coast photographer, specializes in working with actors.

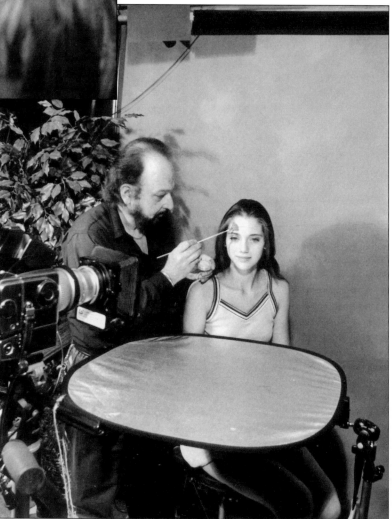

Left: Even a very small room can be converted into a make-up room for models.

Below: The photographer should develop some make-up skills so minor touch-ups can be done when required.

Above: Blemish before make-up correction.

Above: Using a cover-up stick for the blemish.

Left: After proper application of the cover-up make-up.

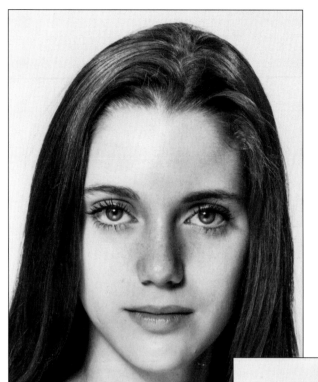

Left: Make-up is important. Shiny nose and no lipstick yields an unattractive image.

Below: Note the improvement by powdering the face (especially the nose) and by applying lipstick.

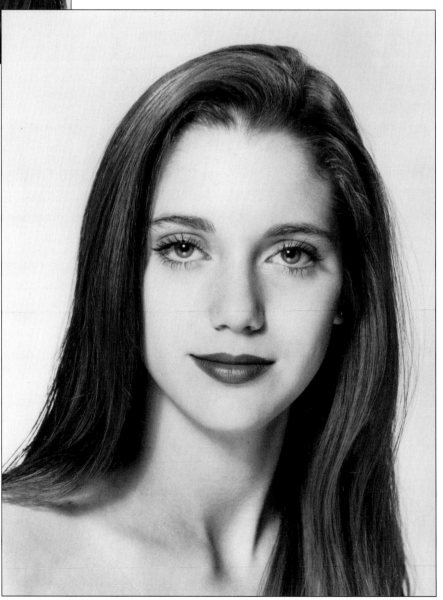

Versace first works with his clients to identify what it is they want to "sell" or what emotions they wish the final images to convey. He then uses a combination of three acting approaches and a behavioral patterning technique to help his clients portray those emotions. Versace's work is based on the premise that, "If you do all the physical activities of a given emotion, your body will trigger that emotion."

Steve Sosensky, another West Coast photographer, tells his models, "Modeling is like acting without the words. Like actors, models are expected to be able to perform on demand. If they don't, a lot of money and time are wasted. Nobody expects you to have a perfect life. We all have problems. Just stuff them in an imaginary bag and leave them by the door when you arrive. If you want, you can pick them up when you leave."

Herbert Ascherman, Jr., a photographer prominent in the Cleveland area for many years, aims to portray his client not only "for who they are, but for who they will or can be." He instructs his models to "close your eyes, pick a thought, open your eyes, and sell that thought." "It is up to the model to project a high intensity moment and it's up to me to capture that moment. That's the show-stopper — a startling image to which the viewer will return again and again."

Some photographers are successful in getting the response for which they are looking by suggesting the model draw on previous experiences or picture themselves in specific situations. Another approach is to focus on the use of various words that elicit desirable facial expressions. For example, having the model slowly say, "Z-o-o" causes the mouth to shape as for a kiss. Suggesting your client say "Gold card" while they think about buying anything they want may elicit a pleased or satisfied look. There are many other words or phrases that may be useful.

Some models respond well to flattery. Statements like, "You have beautiful eyes," or "You have great biceps," can produce a look of self-confidence, amusement, or pleasure. Experiment with your client to see what techniques work best to evoke the specific responses for which you are looking.

"From the model's perspective, you should appear efficient and in control."

Remember that moods are contagious. Your client will not maintain their enthusiasm and concentration if you act bored or distracted. Even if problems arise, you must always maintain a positive attitude. Do not share your concern with your client over any technical problems you encounter. From the model's perspective, you should appear efficient and in control. We suggest you conclude the shoot by complimenting your client on how well they worked and telling them how positive you feel about the results you will get.

Basic to the creation of any good image is a thorough understanding of how to use light. So many books have been devoted to this vast subject that we would be foolish to attempt a condensation here. We suggest you read all you can on this subject because most successful photographers never stop learning about and experimenting with the use of light.

In the studio, it is important to understand how to artificially light your model. Studio strobe units equipped with a modeling lamp are useful in predetermining how the light from the strobe will fall on your subject when it fires. Modeling lamps are a separate light source (distinct from the strobe unit itself) which approximates the direction and intensity of the light thrown by the electronic strobe unit. Some studio strobe units come with a modeling lamp as an integral part of the main unit. All strobes with modeling lamps adjust the intensity of the lamp as you adjust the intensity of the strobe, but only the more costly units have the same number of fractional adjustments for both. Although modeling lamps will help you visualize what the strobe will do, a more exact method of determining the result is to take a Polaroid under the same lighting conditions you plan to use during the shoot.

By using two reflectors for this image, we can bounce light into the model's face and open up shadows.

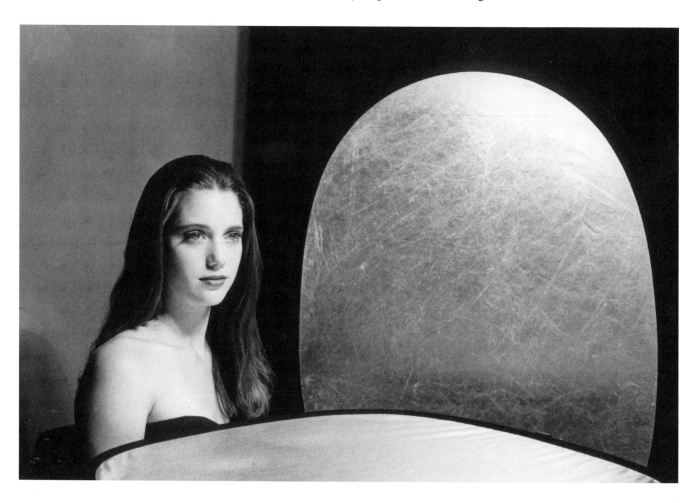

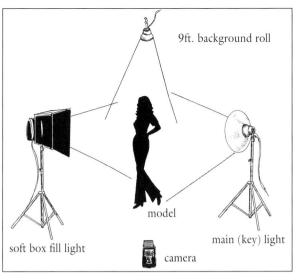

9ft. background roll

model

soft box fill light

main (key) light

camera

Basic Full Length Model Lighting Set-Up

This set-up provides even lighting with soft shadows.

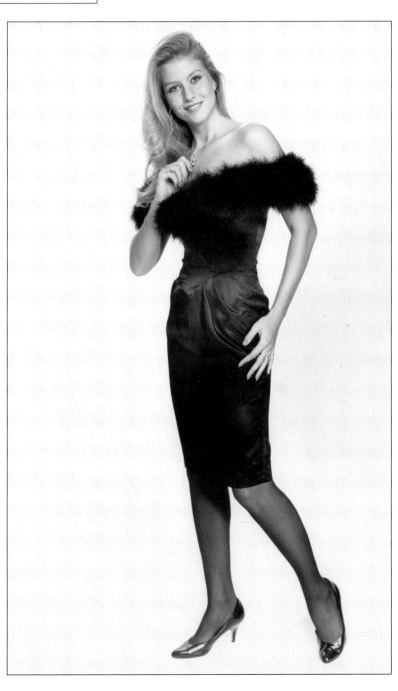

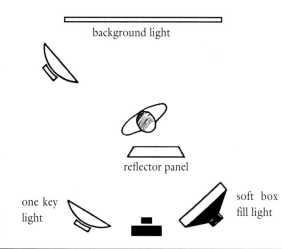

background light

reflector panel

one key light

soft box fill light

Head Shot
Lighting Set-Up #1

This set-up uses a soft box and a reflector panel to diffuse the light. This helps soften harsh features, particularly on mature subjects.

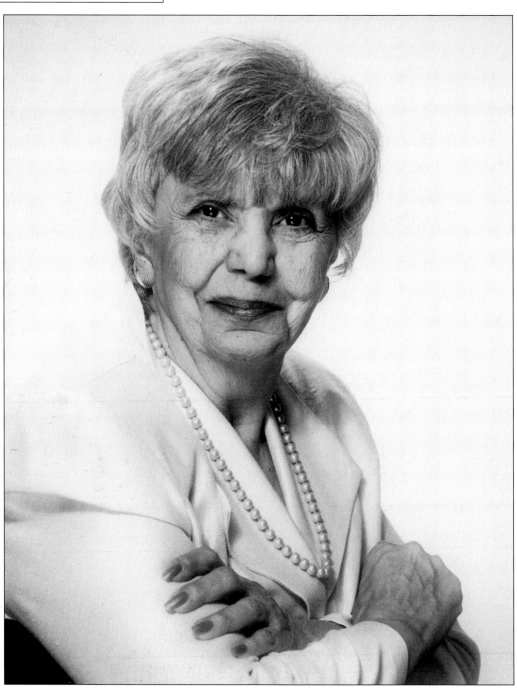

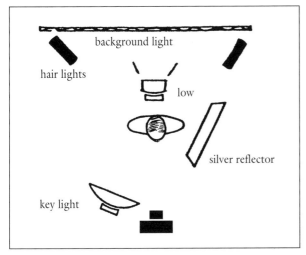

Head Shot
Lighting Set-Up #2

This set-up has the main or "key" light in a high position at a 45° angle to the subject. A reflector is used to fill in the shadow side of the face.

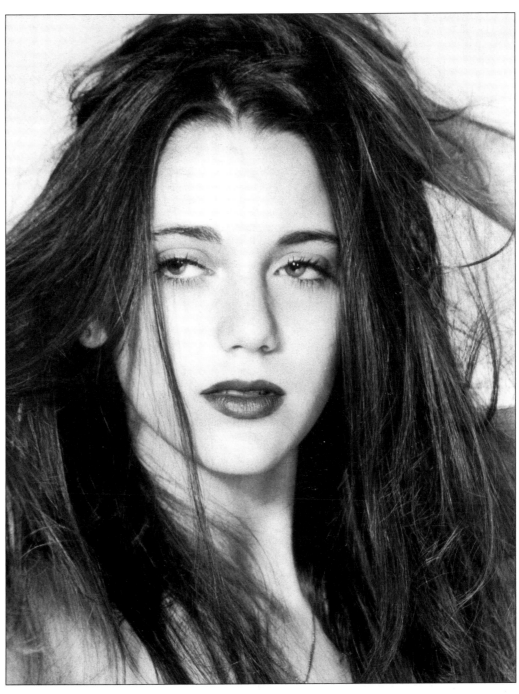

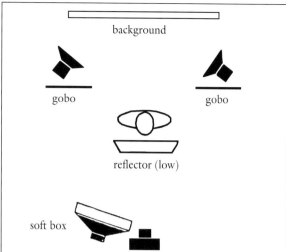

background

gobo gobo

reflector (low)

soft box

Head Shot
Lighting Set-Up #3

This set-up achieves even lighting on the face with a soft "butterfly" shadow directly under the nose.

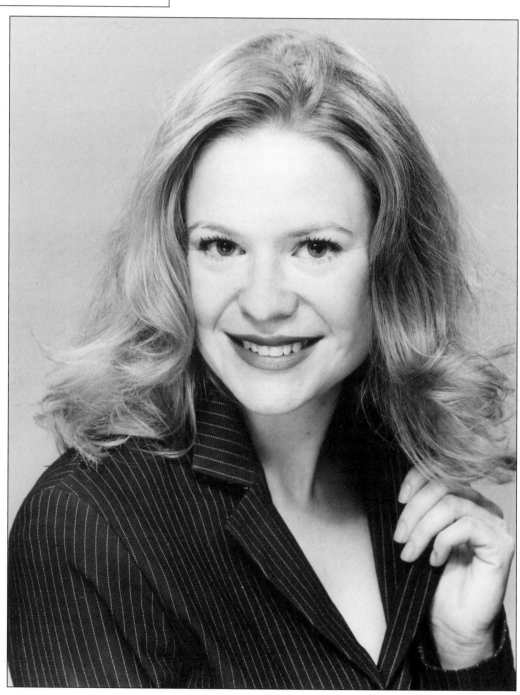

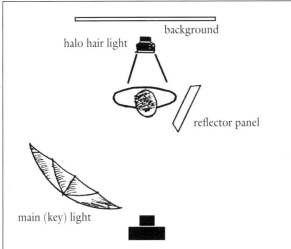

Halo Lighting

This lighting effect accents the model's hair.

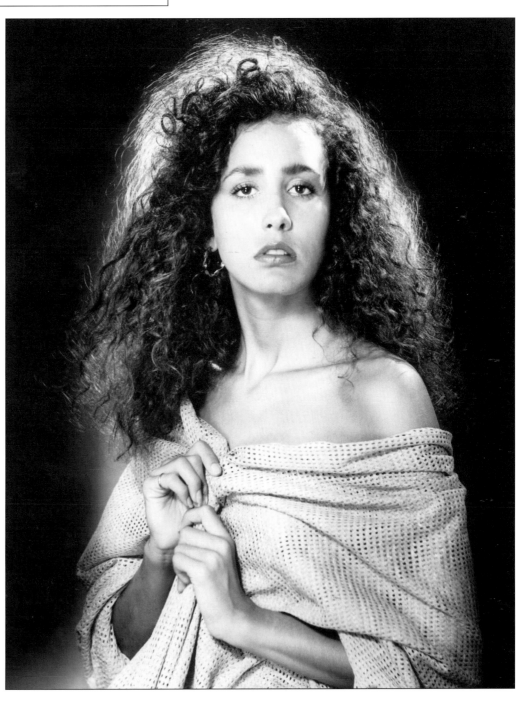

This lighting effect accents the model's hair.

"When shooting a B&W portfolio, you may wish to use continuous studio light sources…"

When shooting a B&W portfolio, you may wish to use continuous studio light sources (often called hot lights) rather than electronic strobe units. Continuous light sources are especially useful because you can leave them on while you evaluate how you want your model lit. Unlike flash, you can see immediately how the light will fall and what shadows it will create. It then becomes easy to add or subtract light or to change the angle or direction of the light and instantly see the result. Be aware that such light sources are usually not balanced for daylight color film. If you wish to use them with any color film, it is best to check their Kelvin rating before purchase. You need to exert some caution when using hot lights because they become very hot. Not only should you avoid touching the lights while they are hot, keep any potentially flammable material from coming into contact with the light housing. Consider using Lexan (plastic) diffusers that clip onto the light housing and over the bulb. These soften the light as well as provide protection if a bulb should break from the intense heat.

The variety of studio lighting units (e.g., electronic strobes, monochrome lights, tungsten lights, hot lights, quartz lights, spotlights, and special effects lights) is considerable. We suggest you contact several of the major retailers in your home town or order catalogues from some of the major mail order houses to get an idea of what equipment is available. Most major manufacturers of lighting equipment have Internet web sites where you can obtain information about their products.

Once you have chosen what studio lighting you will use, there are numerous techniques you can try. To soften and even out the light, try using electronic strobe units in soft boxes or bounced out of umbrellas. Place your strobe units so that the model is evenly lit. You can use reflectors to bounce light into heavily shadowed areas. Pay special attention to the model's face and eliminate as many shadows as possible unless you intend to use shadows to help create character shots. For instance, you may wish to use harsh lighting to create shadows to call attention to or dramatize a client's specific attribute. Look at our illustrations for sample studio lighting set-ups and how they effect the final image.

Superb lighting and perfect exposures cannot compensate for a model who poses awkwardly. Photographers find this a common problem among novice models. Models' portfolio photographers must meet the challenge of teaching such novices while the shoot is in progress. But whether your model is a neophyte or an expert, you always need to play the role of director. How much direction you need to offer however, will vary greatly from client to client. If you know in advance that your client is a novice, you may wish to suggest they watch or buy a videotape on posing techniques. These are available through a number of fashion and photography magazines.

Body Balance & Posing

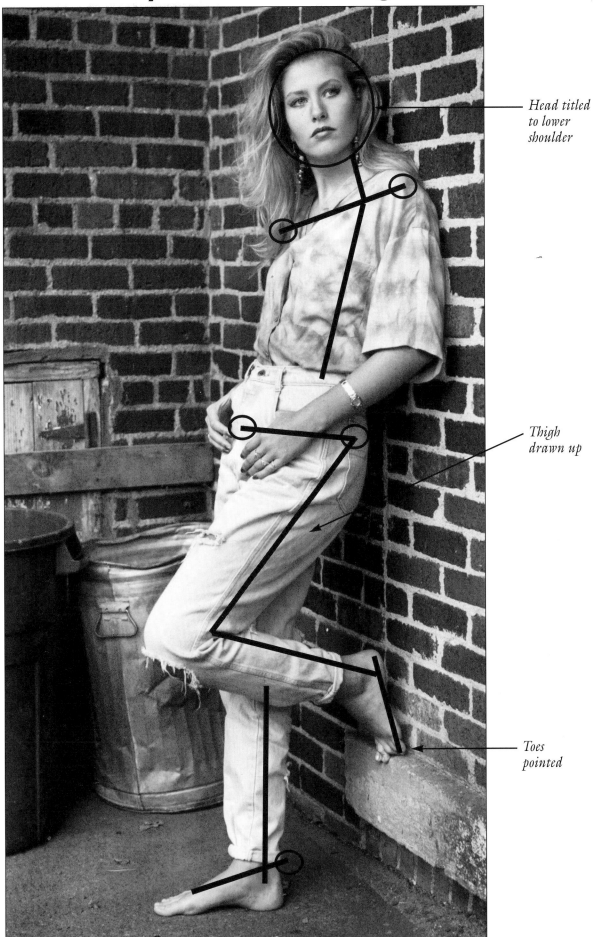

Head titled to lower shoulder

Thigh drawn up

Toes pointed

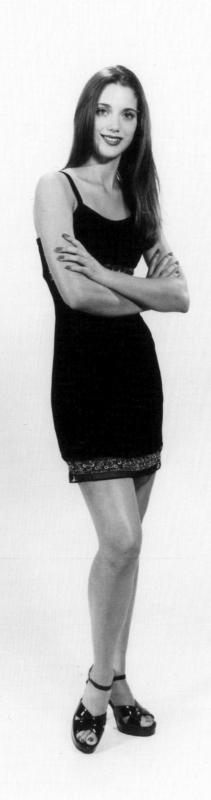

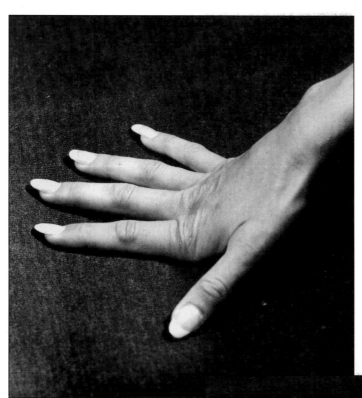

Left: This is a poor hand position — the fingers look "broken."

Below: A good hand position that creates a natural flow of the lines.

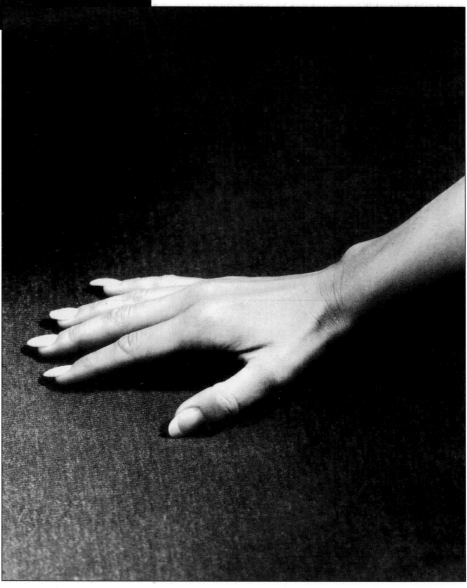

Right: Another poor hand position — the fingers look "broken" and spidery.

Below: In this example of good hand position, the two hands form a pleasing line.

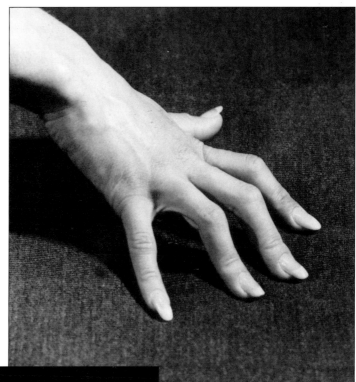

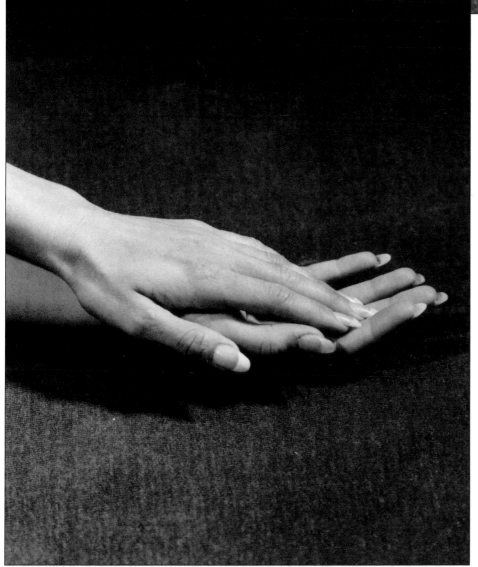

Pay close attention to the angle of the head. A slight turn of the head helps minimize the model's ears because the camera sees only one. If the model is wearing an earring, be sure that the angle at which you shoot is such that the earring on the side of the head away from the camera does not appear to be growing out of their face. You can avoid this problem by having the model remove that earring.

There are a number of torso positions that convey different impressions. A slight twist of the body with a lean toward the camera is one that conveys warmth or sexiness. Conversely, a straight up pose with arms crossed tends to portray an individual as strong, defiant, or stubborn. A lean away from the camera might convey the impression of fear or wariness.

"Hand positions can be exceptionally expressive or excessively distracting."

Hand positions can be exceptionally expressive or excessively distracting. Shooting the hands from the side makes the fingers appear longer and is more flattering than shooting the back of the hand, which draws attention to the veins. Models should keep their fingers slightly separated and bent toward the palm. This makes their hands look relaxed and natural and avoids the claw or mannequin look.

When a client wants to appeal to the fashion or glamour industry, having them point their toes (with or without shoes) makes their legs look longer. This occurs because the angle of the foot created by pointing the toes elongates the image recorded by the camera. Conversely, using a more natural foot position avoids this highly stylized look. A female model who poses with one foot in front of the other creates a stance that tends to show off her legs. If she also turns her body at a slight angle to the camera, the image created will tend to minimize her hips and buttocks.

The photographer must try to be sensitive to the effects that various poses and postures will have on the final images. You may find that you can learn much from your more experienced clients. Even when asked to assume a specific pose, experienced models may offer the photographer a variety of subtle changes in body position and facial expression that offer shooting opportunities the photographer may not have anticipated.

You may want to allow or encourage your client to move in front of the camera so your images of them will appear less static. Many models move more freely and more creatively if they can do it to music. Consider having a way of playing a selection of tapes and CDs that create a variety of moods. If you anticipated the need or if your client prefers, you might suggest that they bring music of their choosing. Whatever the choice, keep the volume low enough so the model can always hear your verbal directions.

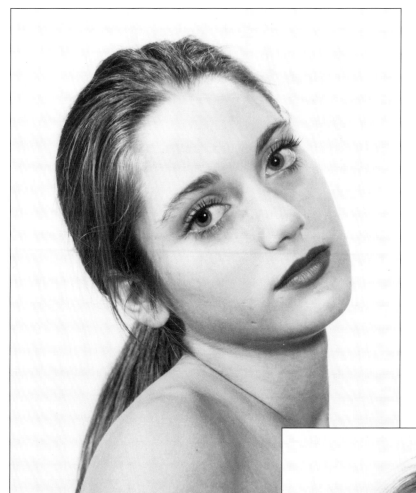

Both of these photos illustrate a poor pose commonly called the "broken neck" position. For more pleasing head positions, see pages 9, 14, 36 and 72.

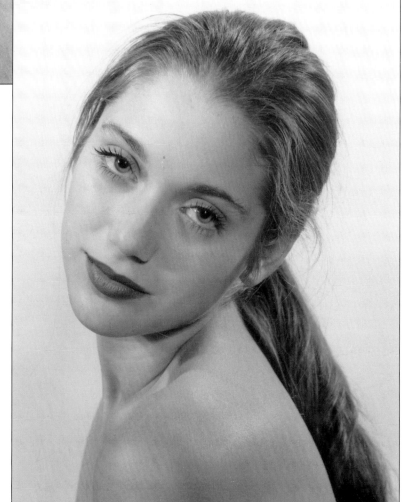

"Be careful to choose angles and perspectives that will be most flattering to your client."

Emphasize your client's most photogenic features and minimize any features you or they think will be viewed negatively by the audience to which they are appealing. If a small-breasted model wants the allusion of a fuller bust, have her wear a push-up bra beneath a snug, low cut top. Then brush the area where her cleavage would be with brown contouring powder (or eye shadow) to create a deep shadow. Then have her lean toward the camera. If a female model needs to minimize heavy buttocks, have her wear loosely draped clothing and shoot from an angle that hides her posterior. A client with a tummy bulge to hide should position their hip towards the camera. Be careful to choose angles and perspectives that will be most flattering to your client. Then carefully adjust your lighting to maximize the effect for which you are looking.

Be conscious of the details that can ruin a shot and do frequent spot checks for them. Strands of hair over the eye, a thread hanging from a piece of clothing, an exposed bra strap, a crooked tie, a missing button, or a sudden slouch are but some of the many small problems that, if undetected during the shoot, may be the very thing your eye will see first on the print.

Try to previsualize the image just before pressing the shutter release and quickly assess whether the clothing, hair, make-up and facial expression are consistent. For instance, a model wearing a laboratory coat should not have a pouty, come-hither expression and one in exercise attire should not look sullen.

Soon, you will have exposed the last frame. After the creative high of the actual shoot has passed, the creative process assumes a slower pace, but it should not end. The successful model portfolio photographer is one who is able to sustain his or her artistic output until the moment they deliver the finished portfolio to their client. After you have captured your client's image on film, you are only partially through the process.

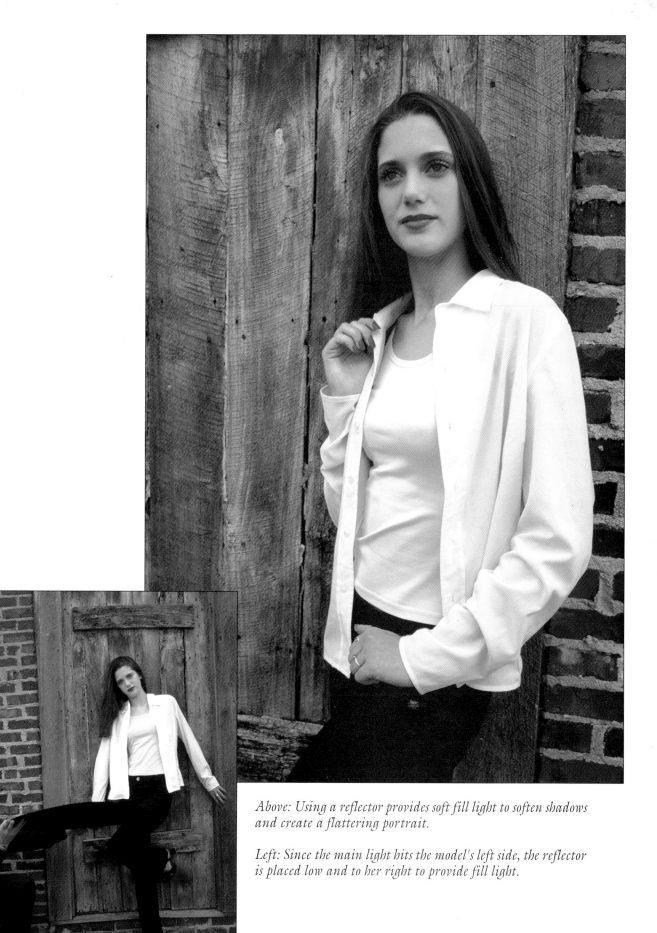

Above: Using a reflector provides soft fill light to soften shadows and create a flattering portrait.

Left: Since the main light hits the model's left side, the reflector is placed low and to her right to provide fill light.

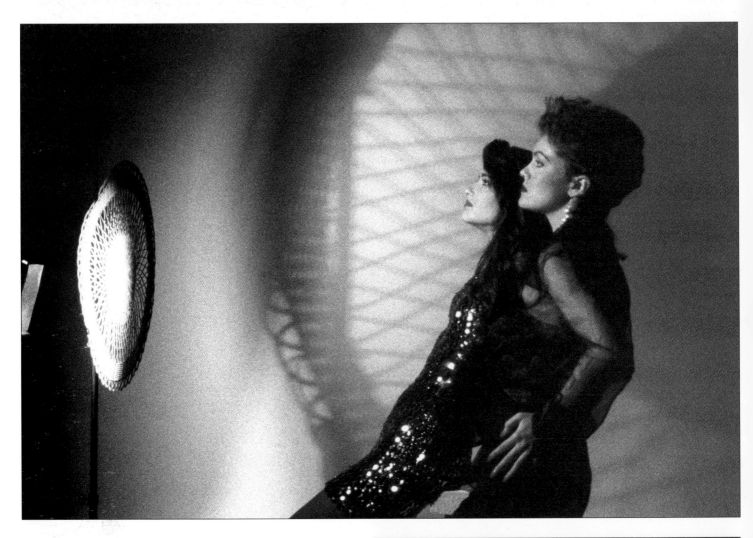

Above: A patterned screen is placed over the light to create interesting light patterns in this fashion shot.

Below: The two models were posed close together around this pedestal.

Opposite: The final result is a dramatic, high fashion image with a unique light effect in the background.

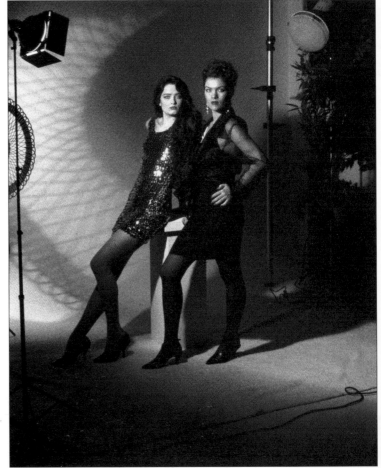

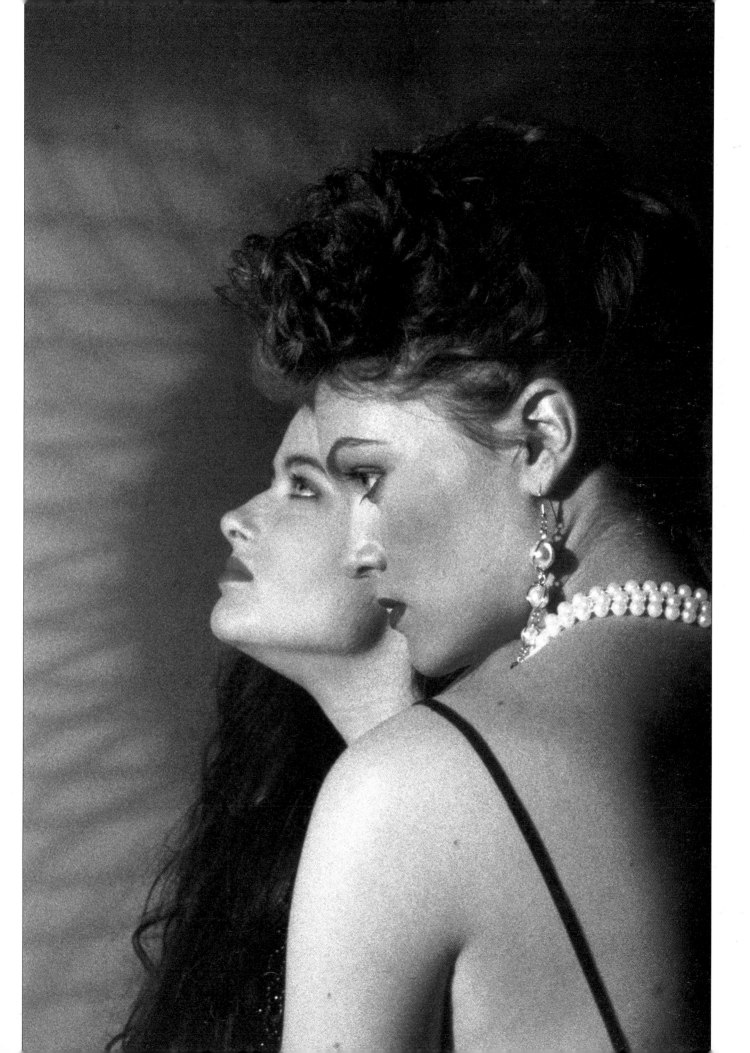

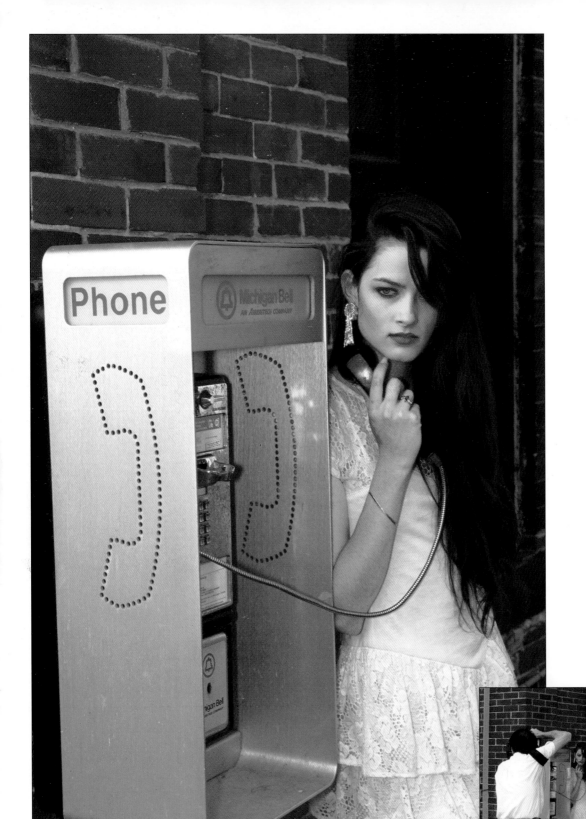

Above: Shooting on location offers opportunities to use a wide variety of interesting backgrounds and props.

Below: A reflector is used to provide fill light.

Above: This photo illustrates poor hand positioning. The thumb is sticking up and looks awkward.

Below: This is an example of a good hand position. Both hands are in profile with one gracefully holding the other.

Left: This is a poor position — the fingernail makes a dent in the cheek

Below: With the fingers curled, the hand is gently placed. This looks graceful and minimizes the dent seen above.

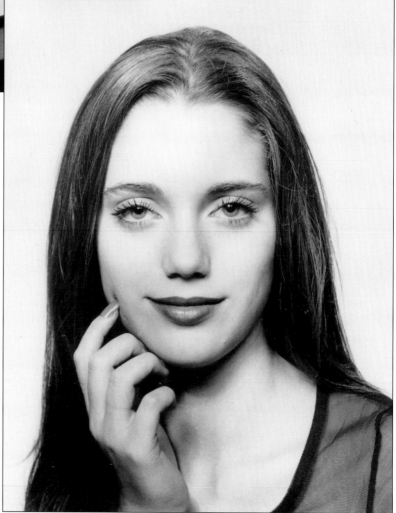

If you have no professional contacts in your area with whom to consult, look for a laboratory in the advertising supplements to your telephone book or one that advertises in photographic magazines. If possible, visit a lab with which you have never before done business before giving them your film to process. Ask to see samples of the work they have done for others. If they are not eager to show these to you, take your film elsewhere.

If necessary, look for laboratories outside your community that advertise in photographic magazines. You will not know what quality to expect however, until you have used them several times. If you are new to this business, you should locate a reliable professional photographic laboratory when you create your sample portfolio(s). Try to build a relationship with one or two specific individuals who work there and ask for them each time you call. You may find such relationships are very helpful when you encounter problems, need special assistance, or even for occasional referrals.

Once your film is developed, obtain two sets of proof sheets. Traditionally, a proof sheet is a sheet of photographic paper with a series of contact printed photographs on it. Most photographers like to have one roll per sheet if possible. All images from the shoot should appear on the proof sheets. The only exception to this is the omission of a roll of film with which you had some technical difficulty. (It is best not to show your client a roll that you fogged in the darkroom.) Even digitally recorded images should be presented as traditional proof sheets so your client has something they can take home with them. Photographers using digital cameras often show images in proof sheet format on a computer screen. We emphasize that, although this is an excellent presentation method, the model should leave with hard copies in hand.

Proof sheets serve a number of purposes. You can record important darkroom information or crop marks for final prints on them for later use, they allow you to review a number of similar poses on one sheet, and you and your client can view and discuss them together. The reason for having two sets is that you can retain a record of the image selections while your client takes one set home for leisurely consideration with her agents, representatives, or advisors. We recommend that you record darkroom notes on the proof sheets that you retain. Using a red grease pencil, record specific printing data under those negatives you print. For B&W, you might want to note the printing date, the f-stop of the enlarging lens, the multi-contrast filter number or the paper contrast, and the size you printed. By drawing on the print, you can indicate areas you burned, dodged, or cropped. All this makes reprinting much easier and avoids repetitive testing and paper waste each time there is a reorder.

Quick Tips

The model should leave your studio with hard copies of the proof sheets in hand, even if you use digital images as a presentation method.

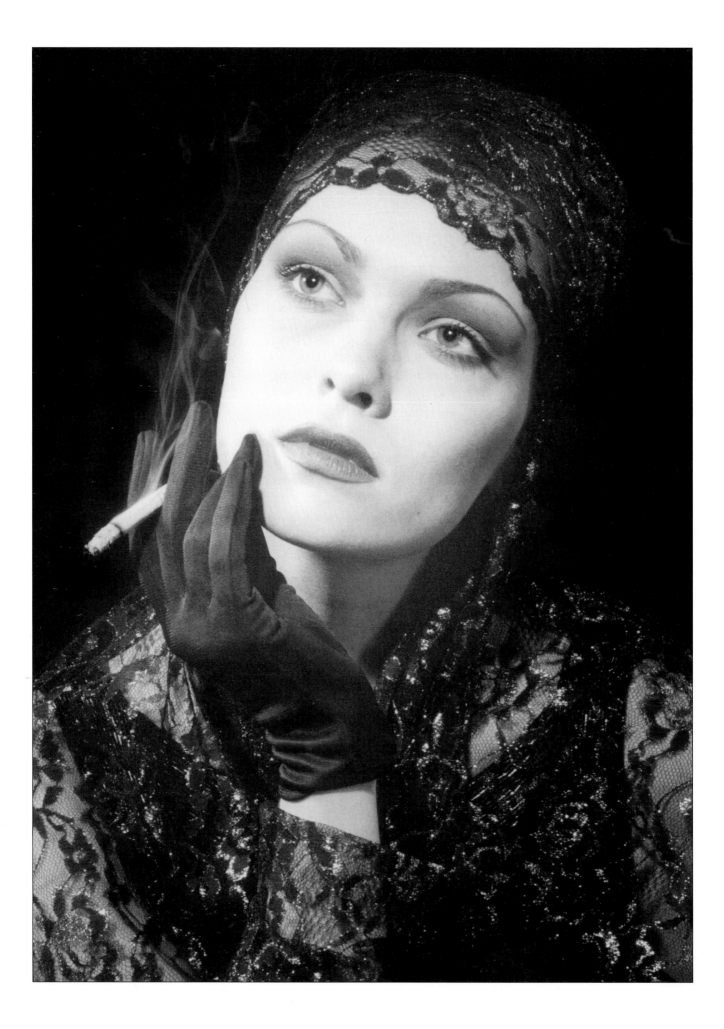

Examples of fashion shots for a portfolio. The photo on the opposite page is a head shot using black lace as a head wrap and cigarette to portray a 1940's European look. The photos above and below demonstrate different poses using the same outfit.

"It is best to protect your negatives by placing them in an archival quality enclosure."

We suggest that you file any signed releases or contracts (or copies if you choose to file the originals elsewhere), the negatives, and the proof sheets in a 9x12 envelope. In addition, consider placing a record of orders in the same envelope. It is best to protect your negatives by placing them in an archival quality enclosure. (Archival quality materials are those that, when in contact with a photographic image for a long time, will not react with it thereby preventing it from deteriorating or discoloring.)

On the outside of the envelope, record the client's name, date of the shoot, and whether or not you have a model's release. Include any other information you think important such as a category into which the images might fall (character, high fashion, sports, etc.), if they were used for purposes other than the portfolio, or client comments. You can then store the envelopes in a standard file cabinet in alphabetical order by client name. If the cost is not prohibitive, it is a good idea to use fireproof files or files placed in a fireproof room or safe. Some photographers prefer to store their negatives, proof sheets, and paperwork in three-ring binders. The limitations of this system are that any paperwork not 8x10 or 11 inches (such as model releases) is difficult to store and you may accidentally tear or lose paper items when turning pages. If your business is heavily computerized, you may be able to store and track all but signed documents using databases and digitized images. The degree to which you decide to computerize is dependent on both your budget and computer knowledge.

After you have completed sets of proof sheets, carefully review all the images before you meet with your client. Begin by grouping the sheets by type of shot. It is easier to select the best shot of a particular type if you can view them one right after another. Use a red grease pencil to mark the images you want the client to consider for inclusion in the portfolio. When you make the selection, keep in mind several things already discussed.

1. The image should be consistent with the goals your client or their agency have for the portfolio. (See Chapter 1.)

2. Select images that emphasize your client's versatility.

3. Pay attention to the background. A damaged background can ruin an otherwise great shot.

4. Nothing in the image should distract attention from your client.

5. The lighting must appear as you envisioned it would. Do not select shots with distracting shadows or highlights on uninteresting or inappropriate image elements even if the client's pose is marvelous.

Examples of office/business poses. This professional look can be used to show the diversity of a model.

Examples of the professional look. For models interested in working with advertising agencies, the office/business look is a good addition to their portfolio.

6. Make sure the emphasis is on the client's best features.

7. Pay close attention to even the smallest elements of body position, hair, make-up and costume.

8. Make sure the model's clothing, hair, make-up, and facial expression are consistent with the image that particular shot is trying to convey.

9. If your client insisted you take a shot using a pose, prop, or outfit you thought would not work and you complied, but then also took a variation you thought might be more successful, present both. Be prepared to explain if either worked and why.

When preparing the proof sheets for presentation to your client, mark those images you want your client to consider for inclusion in the final portfolio. Remember, if you give your client too many choices, they may have a difficult time making the final selection. Also, if the contract includes a composite card, indicate separately which of the images you think your client should consider for this specific purpose.

After marking both sets of proof sheets, call your client for an appointment. When they come in, go over the proof sheets with them indicating each image you have selected. Try to give them a specific reason for each selection. Review what you understand your client's goals to be and how your selection best achieves those goals. If it is not clear from your grease pencil markings, indicate to your client how you suggest an image should be cropped and whether it should be presented as a horizontal or a vertical. Encourage your client's input.

This is a good time to reinforce the feeling that the final portfolio is a result of a cooperative effort between model and photographer. Listen carefully. Your client may have valid reasons for including images you did not select. Try to discourage your client from selecting too large a number of images for the portfolio. If necessary, review again with them the goal of the portfolio; that it should be brief enough to hold an agent's attention, but varied enough to show your client's versatility. We recommend using a maximum of twenty images.

Before your client makes any final decisions about which images to use, tell them to take the proofs home and show them to their agents, representatives, advisors, friends and relatives. Most clients are eager to do this, but if you have one who wants you to decide for them, suggest that this be their decision. You can tell them which images you like, but make sure they get others' opinions before signing off on the selection.

"Your client may have valid reasons for including images you did not select."

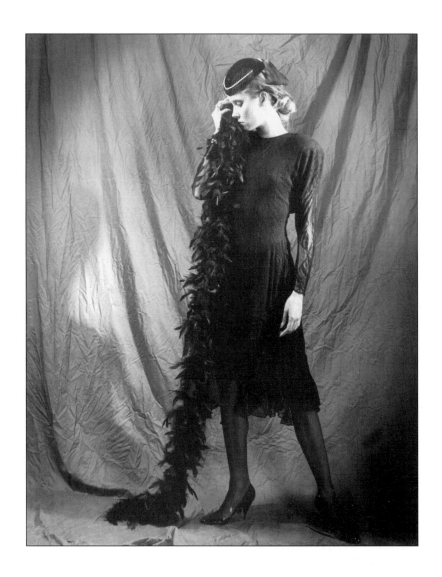

Left: A dramatic full-length shot for a fashion or acting portfolio. A plain muslin background was used.

Below: A proof sheet including crop marks made by the photographer and other printing notes.

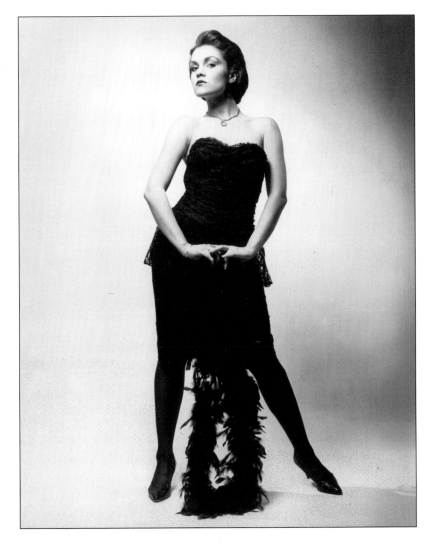

Above: The proof sheet is invaluable to the photographer for picking which shots to print and how to crop them.

Below: Another example of a full-length image for an actor's or model's portfolio.

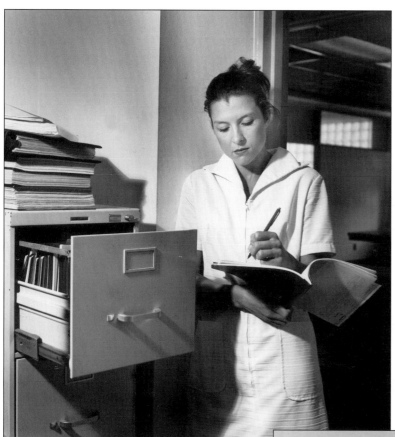

Left, below and opposite page, top: These are all examples of an on-location shoot using office equipment to create character shots for an actor's portfolio.

Opposite page, bottom: One of the proof sheets of the on-location photo session.

Explain that because their talent or model agent knows what will appeal to their clients, the agent may want to see all the images and have some input into which will finally appear in the portfolio.

In addition, some models or performing artists are represented by more than one agency and each one may want a different selection of images depending on their clientele. Your model will then have to make a compromise to keep both agencies happy or might have to have two portfolios. It is to the photographer's advantage to have the client show the proofs to as many people as possible. Each person who sees them is a potential buyer of prints or a potential client.

If your client has already contracted for a composite card, take this time to show them the standard layouts from those companies you like to use. Give them your suggestions for the layout and tell them what information you think should be included such as height, weight, torso measurements, eye and hair color, dress and, if pertinent, shoe size, types of modeling or acting done, and types of modeling or acting desired. Reiterate that they should consult with their advisors and agents before finalizing the layout.

If your client has not already contracted for a composite card, show them which images you would use for one if they should change their mind. Remind them that it is not a good idea to leave their portfolio with an agent as it may be misplaced; leaving a composite card is preferable. In addition, when your client visits a new agency, an agent may not be available or may be too busy to immediately view the portfolio. Leaving a good composite card may be enough to capture the agent's attention so they later call and request an interview. Assure your client that should they decide to have a composite card created, arrangements can be made at your next meeting. Before your client leaves, either set up your next appointment or ask them to call after they have made their print selections.

The purpose of the next meeting is to finalize print selection for the portfolio, composite card if ordered, and additional prints if desired. (If your client ordered a composite card, now is the time to get the statistics and information you need to make up the card.) It is at this meeting that you should present your client with a sign-off sheet. This document verifies the number, identification, and size of all images to be printed. Minimally, the sign-off sheet should contain the following elements:

1. The identification by negative number (or other numeric system) of each image to be used for the portfolio.

2. The identification by negative number (or other numeric system) of each image to be used for the composite card, if ordered. Include a brief description of the layout and the information you think should be included on the card.

3. The identification by negative number (or other numeric system) of each image to be used for extra print orders. Indicate the size and quantity of each negative number.

4. Costs for add-ons not already covered in the contract.

5. A statement that the client authorizes the photographer or studio to prepare prints as described and agrees to be responsible for the payment of the charges indicated which are in addition to the original contracted amount.

6. An area for the client's signature and the date.

"Go over any options you want your client to consider..."

Make sure your client understands that they must sign and date the sign-off sheet before you will go any further with their order. Go over any options you want your client to consider before you put the final portfolio together. For instance, your client may wish to change the type of binder or portfolio carrier they ordered or they may want more than one composite card. Because your next meeting will be for delivery of the items ordered, make sure your client is aware that this is their last opportunity to make changes or additions to the services for which they originally contracted.

Left, below and opposite page, top: Various shots of children.

Opposite page, bottom: An example of a composite card made for two brothers.

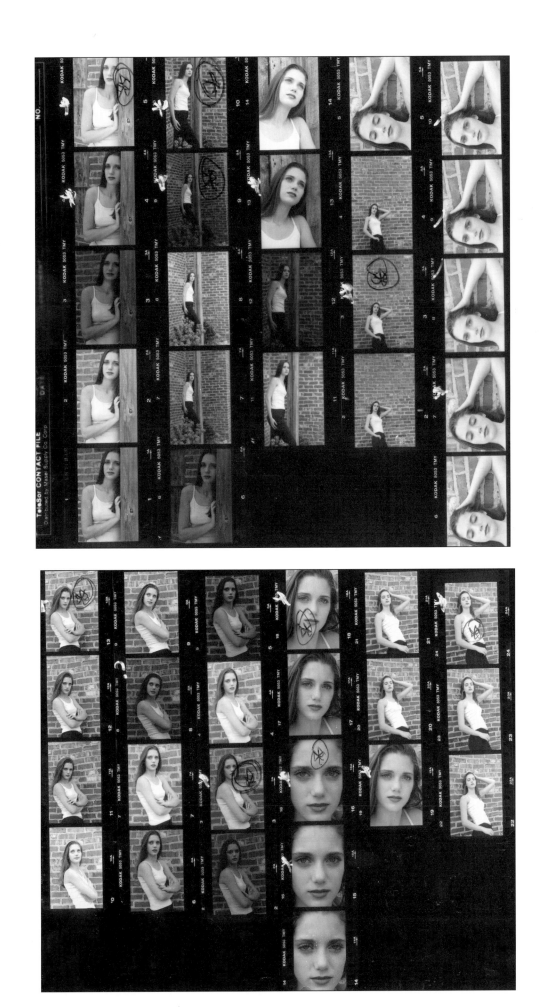

Design, Printing, Packaging & Delivery of the Finished Portfolio

"You must display the photographs within the portfolio so they will have the most impact…"

There are a few final steps you must take before you can deliver the finished portfolio to your client. You must display the photographs within the portfolio so they will have the most impact, keep your costs in line with those you projected in the contract, and give your client a showpiece of which they can be proud.

In the past, models often carried a portfolio of 16x20 prints. Besides the obvious transportation problems, agents found their unwieldy size an annoyance. Most agents could not find room on their desk for anything so large. We recommend that our clients carry nothing larger than a case containing 11x14 prints.

It is important that you assemble the portfolio in such a way as to allow the viewer to feel that one image follows another in some natural sequence, almost like reading a book. We frequently use the best head shot as the opening image. This introduces the viewer to the client and forms the first (and strongest) impression. You may vary the sequence that follows depending on the audience to which your client is appealing. Try to keep the simplest looks first, gradually building to the most exotic, glamorous, or unusual. Try to end with a powerful image.

Plan the portfolio so that multiple copies of your client's composite card or one-page resume, with their business card attached, can be displayed. These can fit nicely into a pocket in the book jacket or into a clear envelope-type enclosure following the photographs. Your client should leave a resume and attached business card (or composite card) with whoever interviews them.

The photo on the opposite page and those on the following two pages are examples of composite cards which a model might elect to have in addition to a portfolio.

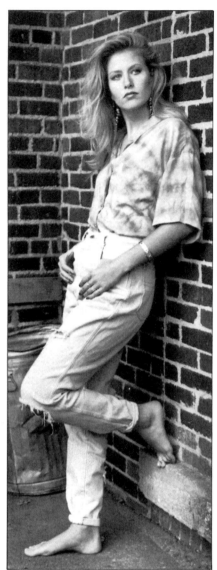

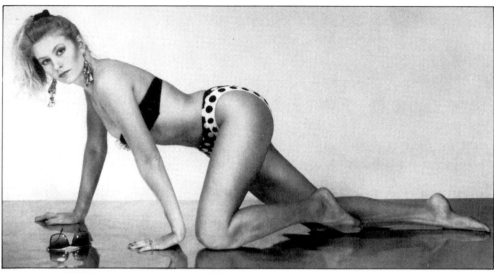

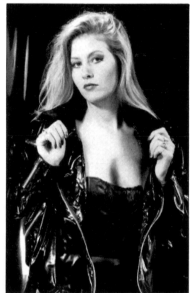

Height 5'8" - Hair Blonde
Eyes Blue/Gray - Dress 5/7 - 35/26/36
Excellent Hands & Legs

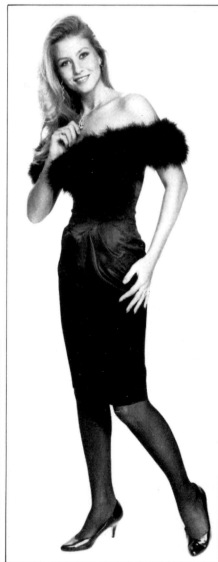

TRACI MENOCH

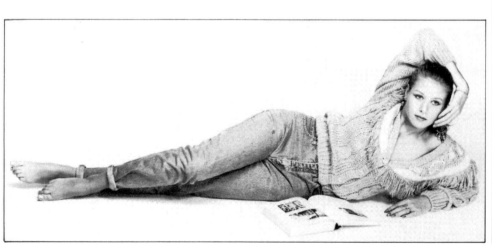

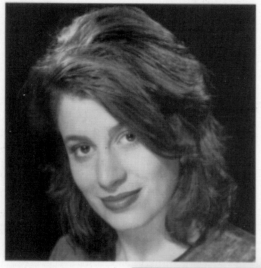
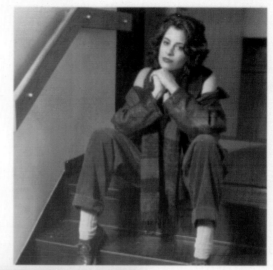

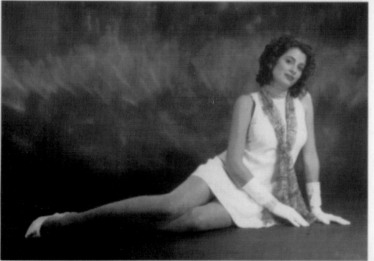

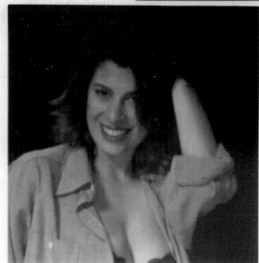

Ht: 5' 8"

Hair: Brown

Eyes: Lt. Brown

Meas.: 36C-26-35

Dress: 7/8

Shoe Size: 8

Excellent Legs

ILARIA GRUPIDO

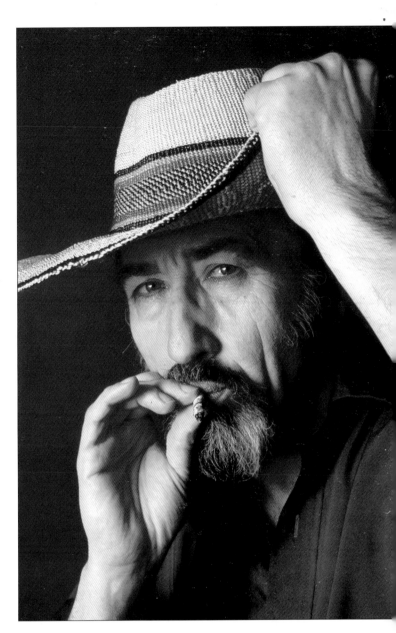

Left: The head shot is an important component of an actor's or model's portfolio.
Right: By adding simple props, it is easy to move from a head shot to a character shot without major changes in lighting or posing.

Working on location, it is possible to create a wide variety of different fashion looks for the male subject.

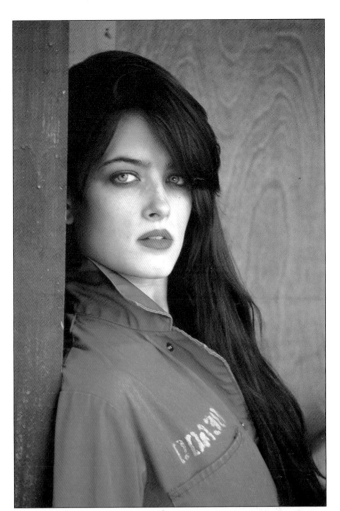

Location shoots also offer opportunities to work with diverse backgrounds and poses to shoot unique fashion images with female models.

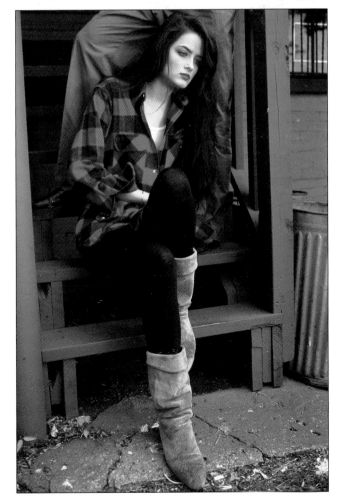

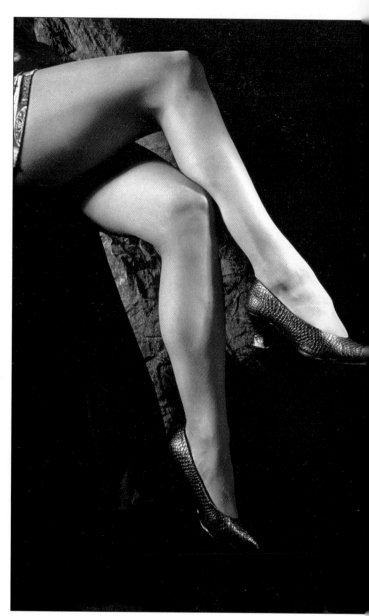

Left: A unique location and pose, and a high camera angle, are used for this fashion shot which strongly highlights the model's legs.

Right: Also a leg shot, this studio image demonstrates a very flattering position to emphasize the shapeliness of a model's legs.

There are many different poses and props that can be used to vary the images in a model's portfolio.

You can then place the pages into a metal or plastic binder that is an integral part of the case. Many photographers and their clients prefer to use a portfolio box into which they place individually mounted prints. These come in a variety of sizes, depths, and colors. There are carrying cases specifically designed to hold portfolio boxes, as well as boxes that already have latches and a handle. A less expensive option is to use a standard three-ring binder into which you place top-loading, archival sheets. Also available is a presentation binder that folds back on itself to form an upright easel. The pages are then flipped over for individual viewing. This choice does not lend itself well however, to viewing vertical images.

For a slightly different look, you can dry-mount the photographs onto heavy card stock and have the pages bound so the result looks like a hand-made book. We suggest you look in your photographic magazines and get on the mailing list of companies that make these items so you can obtain their newest catalogues. Visit your local art store for other ideas not promoted specifically to photographers. Avoid any scrapbooks you see in discount stores, especially those that advertise "magnetic pages." Using these not only produces an amateurish looking portfolio, they are frequently made of materials which can damage the photographs.

Regardless of whether your images were originally recorded on film or electronic media, you must decide on what kind of paper to print your images and whether to do them yourself. A good photographic service bureau can scan your negatives into a computer and generate the prints from the files created so even the traditional photographer may elect to use electronic printing. If you choose to have either a professional photographic laboratory (in the case of film) or a service bureau (in the case of electronic media) do your final printing, the same cautions about choosing a laboratory that we discussed in Chapter 5 apply here. You must know what quality you can expect, how efficiently they will respond to your instructions, and if they honor their delivery dates. In addition, find out if they guarantee their results. A good laboratory or service bureau will usually reprint, at no charge, any print they make that does not conform to your instructions.

When delivering single extra prints, avoid placing them in any envelope that has a metal clasp. The prongs that secure that clasp to the envelope can scratch the print as it is removed from or inserted into the envelope. If you want to use this kind of envelope, place a piece of masking or packaging tape over the prongs before inserting the prints. It is best to obtain plain envelopes of the appropriate size.

When you call your client to tell them their order is complete, set up an appointment that includes a short meeting. There is some additional business to conduct and there are several items you

A character look for an actor's portfolio.

Right: An on-location business fashion shot. The briefcase is a good prop for these types of shots.

Opposite page: Another example of a professional look for a model's portfolio.

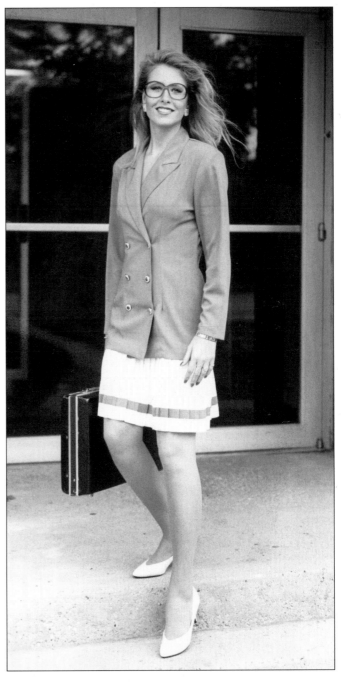

should discuss with your client before they leave with the finished product. When you call, make sure they understand they must pay any unpaid balance before you will release any of the materials to them. Regardless of the hard luck story you may hear, do not become trapped into releasing partial orders. Make sure your client knows that if they pay by check you will need to see their driver's license and a credit card. Write down the license number, license expiration date, birth date, current address, credit card number, name as it appears on the credit card, and credit card expiration date. Some photographers find it a good idea to accept Visa or

A high fashion shot.

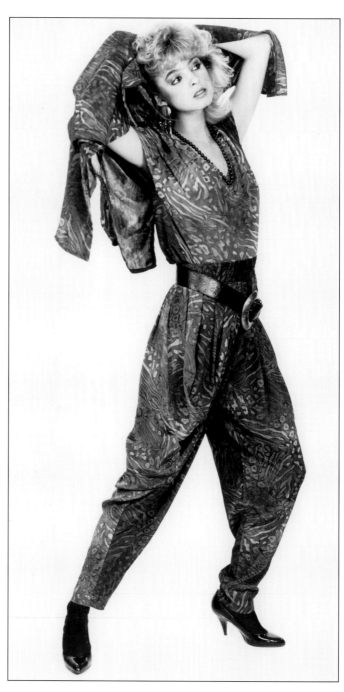

MasterCard, while others accept only cash, a money order, or a bank draft.

When your client comes in for their final appointment, have them sign a final sign-off document. This document should contain a statement that confirms the client has received, in good condition, all items that they ordered. Additionally, it should state that the client understands that any damage that may occur to these materials after they take possession is their personal responsibility. Provide an area for the client's signature and the date.

"The more successful your client becomes, the better your chance of getting repeat business and referrals."

Like all documentation, you should retain the original and give your client a copy. If your client did not order a portfolio case, advise them to quickly place the images in a protective case of some kind.

Spend a few minutes going over the portfolio with your client. Point out how the portfolio satisfies their initial goals. If they are receptive, and especially if they are novices, we like to make a few suggestions about how they might use their new portfolio to further promote their career. They need to understand that they are their own best promoters. They should make visits to as many potential clients and agents as their time will allow, leaving a composite card and resume at each one. Suggest they send composite cards or head shots to the advertising or public relations department of local convention halls and any corporation for which they think they are specially suited. Large local malls frequently feature fashion shows. Your client should visit and leave a composite card with the fashion show producer. If your client decides to do some advertising, either in local newspapers or by hanging their business card up anywhere, suggest they list the telephone number of a voice mail service. Caution them not to make their home address or telephone number public. The more successful your client becomes, the better your chance of getting repeat business and referrals.

End your conversation with lots of positive reinforcement. Hopefully, your client will be so impressed with their portfolio and your services that you will receive kudos in return. One final note — do not let your client get away without giving them a supply of your business cards. They will need them to give to all those who see their portfolio and cannot wait to flock to your door.

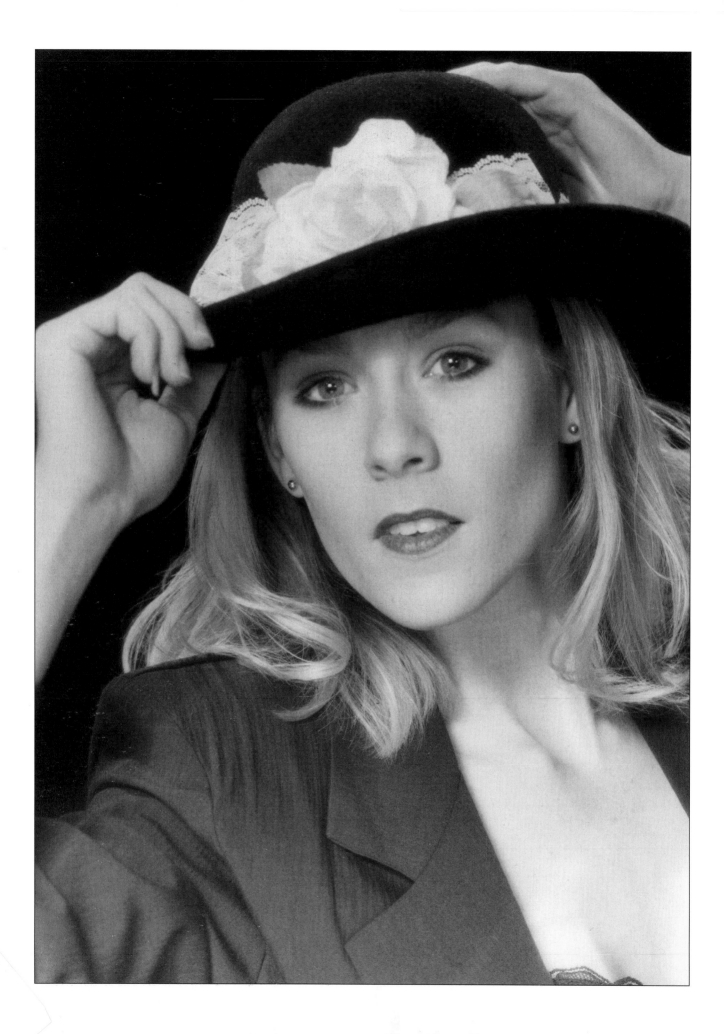

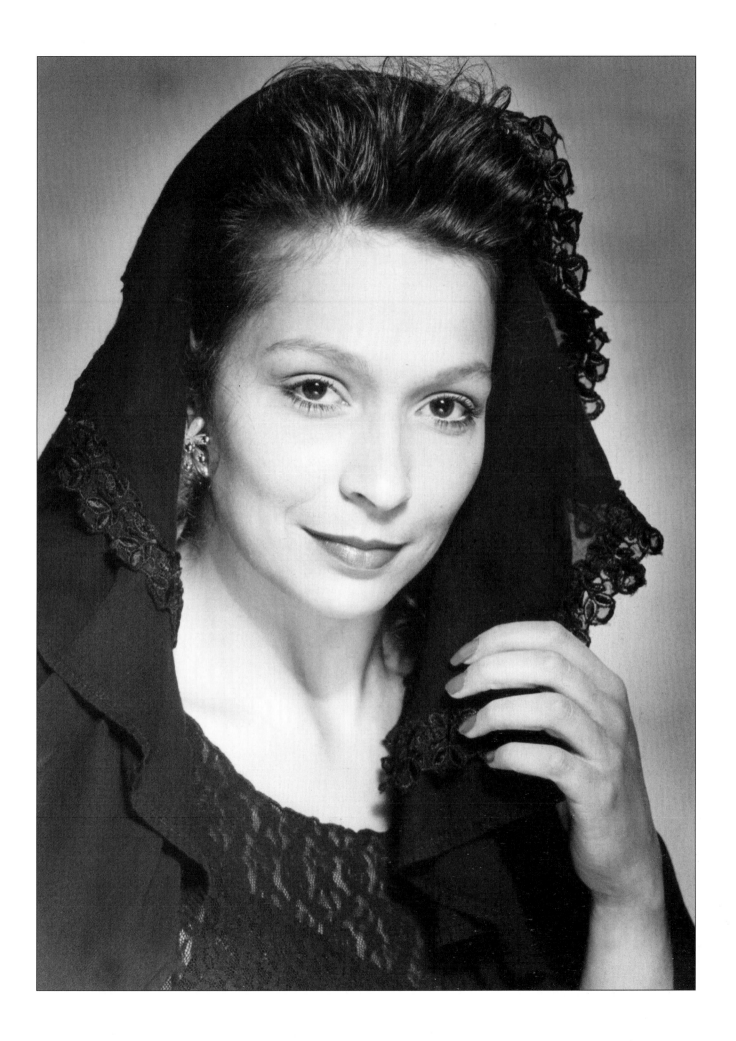

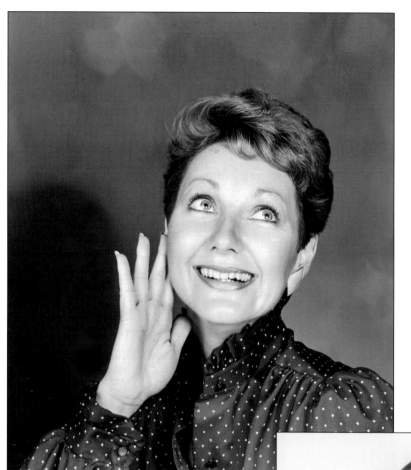

The photos on this and the opposite page are part of a series shot for a theatrical and fashion portfolio.

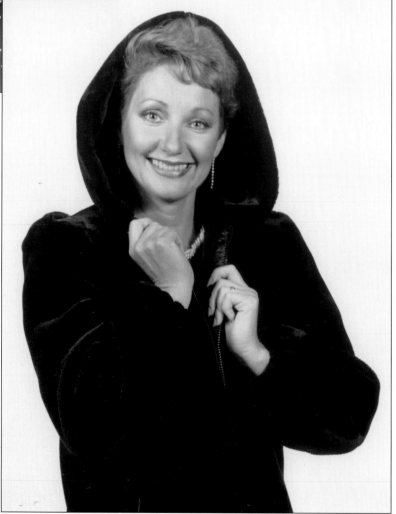

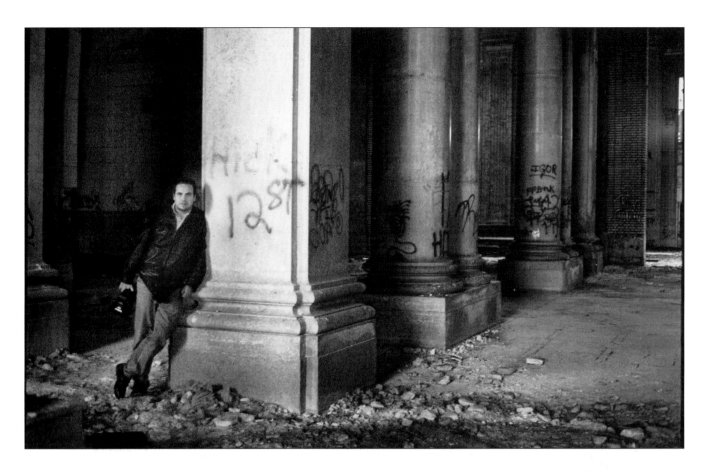

Two final prints (and a proof sheet from which they were selected) from an on-location session for an actor's portfolio.

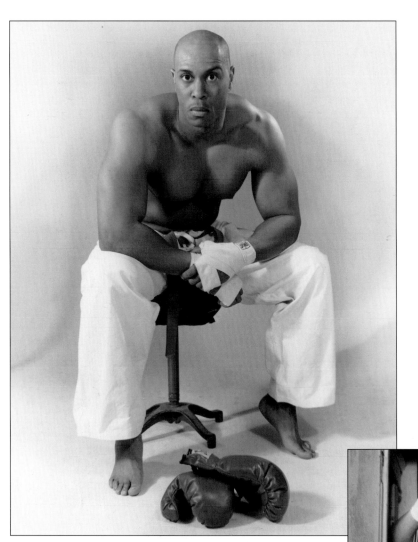

A series of shots that display the model's strongest features.

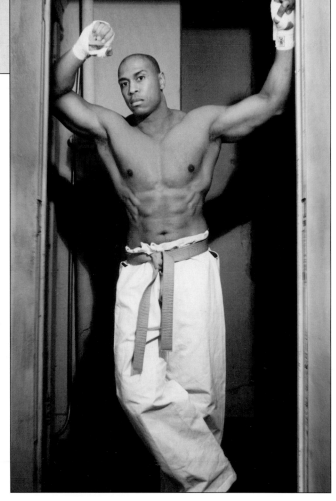

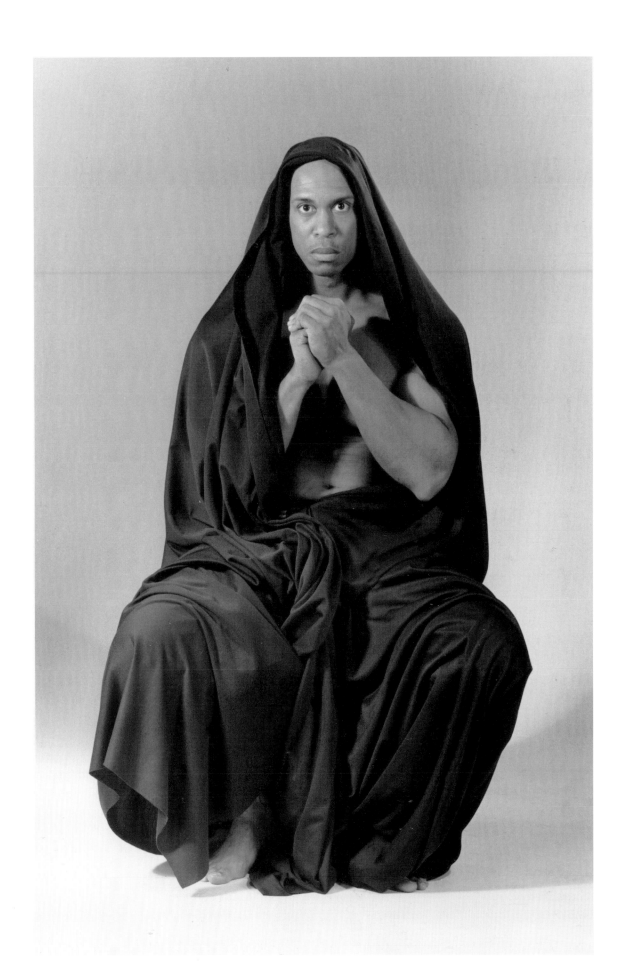

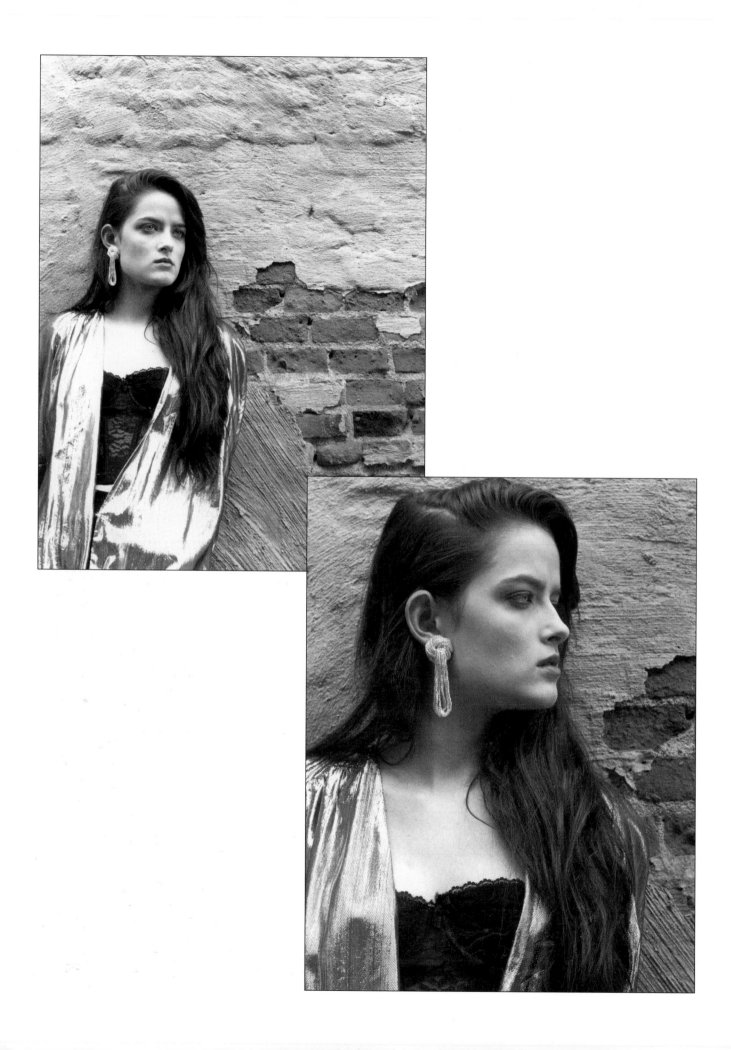

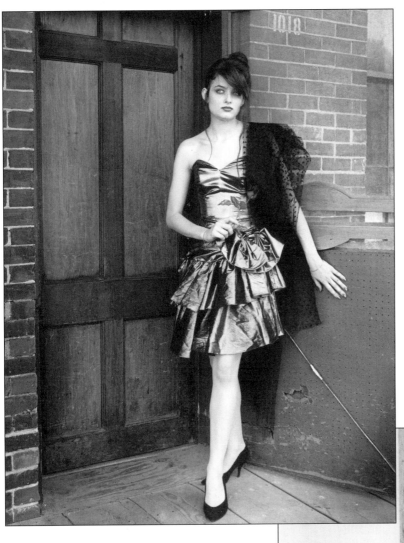

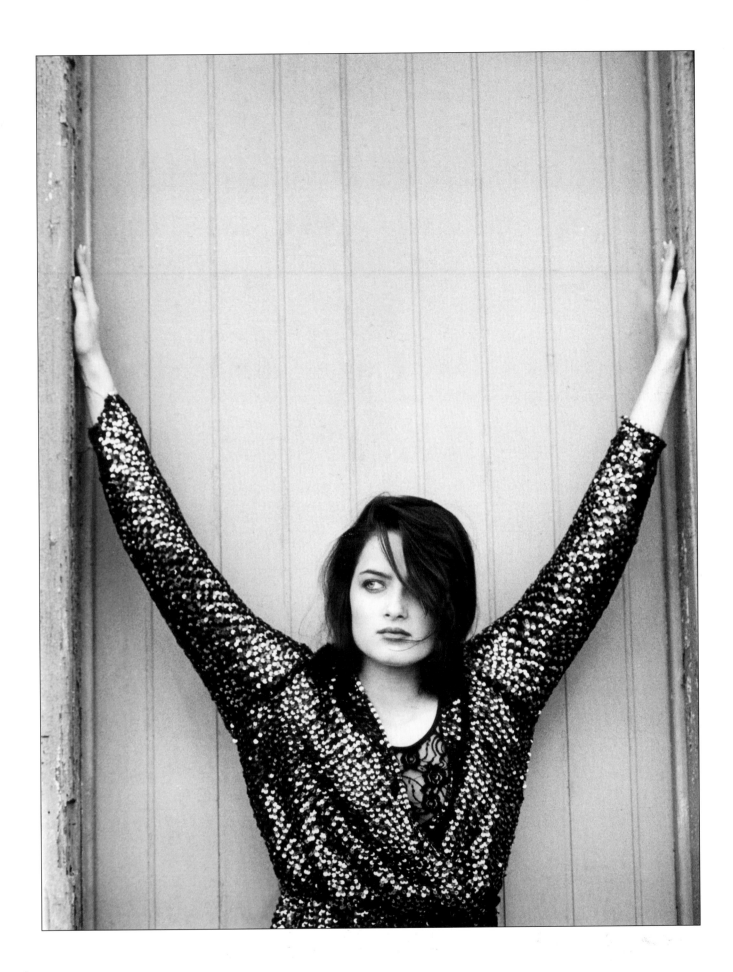

Index

a
accessories 15, 23, 37
additional personnel 15, 24
 clothing stylists 15
 hair stylists 15
 make-up artists 15, 24
adjustable posing stool 37
advertising 7
advisor 10, 19
ambient light 40
American Society of Media Photographers (ASMP) 28-29
agency 10, 14
archival quality prints 96
artificial light 46
Ascherman Jr., Herbert 45
attracting clients 7

b
backgrounds 38, 76
batteries 37
business cards 7, 103
butterfly lighting set up 50

c
cable release 37
checklist 39
clothing stylists 15
composite cards 23-24, 79, 84-85, 96, 103
continuous light sources 52
contract 15, 18-29, 76
 add-ons 24
 disclaimers 28
 granting usage rights of images 29
 package types 25-26
 payment terms 26, 28
 services 23
 waivers of liability 28
contract add-ons 15, 24
 additional personnel 24
 composite cards 24
 extra rolls 24
 portfolio cases 24
 rush jobs 24
costs 26
 film 26
 final prints 26

personnel 26
portfolio cases 26
rental fees 26
special processing 26
time 26
cameras 37-41
 digital 37, 73, 76
 medium format 37, 40
 35mm 37, 41

d
day rate package 25
delivery of the finished portfolio 98
deposits 18-19
designing the portfolio 84, 92, 96
 final shot selection 96
 layout 84, 92, 96
 final print selection 84, 96
digital format 37, 73, 76
disclaimers 20, 28

e
electronic flash 37
equipment 37-52
 cameras 37
 lighting 37
exposure meter 40
extra rolls of film 24

f
fashion modeling 14, 16
fiber-based photo paper 96
film 23, 26, 37-38, 40, 70
filters 37
 polarizing 37
 soft focus 37
 special effects 37
final appointment 102
final prints 26, 84, 96
flash meter 40
flat fee package 25
full length lighting set up 47
full length shots 11, 35

g
glamour modeling 16
goals 5, 10, 14-15, 79, 103

h
hair 15, 33, 41
halo lighting 51
head shots 11, 35, 41
head shot lighting set ups 48-49
high gloss finish 96
hot lights 52

i
images sizes 92
initial contact 7

j
jewelry 23

l
labs 70, 73, 98
lens shades 37
light meter 37, 40
light stands 37
lighting 46-52, 76
lighting diagrams 47-51
lingerie modeling 11, 16
location permits 39

m
make-up 15, 23, 25, 33, 41
matte finish 96
medium format cameras 37, 40
minors 7-8
model releases 29, 76
modeling lamp 46
monetary penalties 28
music 62

n
National Press Photographers Association 29
natural light 40
negatives 29, 76, 84

o
on-location 11, 15, 18, 23, 37-39, 41
 alternative sites 39
 permits 39
 specific sites 39

p
parts modeling 15
payment terms 20, 26-28, 101-102
personnel 15, 23, 26
photo paper 96
 fiber-based 96
 resin-based 96
Polaroid test shots 40, 46
portfolio case 14, 25-26, 96
portfolio layout 84, 92, 96
posing 52, 55-62, 64
pre-shoot discussion 7, 10-11
pre-testing equipment 37, 40
preparation for the shoot 30
price per roll package 25
pricing 9-10, 15, 25
 packages 25
 payment terms 20, 26-28
 range of prices 10
processing film 23, 26, 70
proof sheets 35, 73, 79
props 15, 18, 23, 33, 38

q
quick release mechanism 41

r
re-ordering 73
re-shoots 28
referrals 103
reflectors 37
refund policy 28
relaxing the model 45
rental fees 26
resin-coated photo paper 96
rush jobs 24

s
sample portfolios 11, 14-15
service bureau 98
services 23
shot selection 70, 79
shooting day 33, 40
shooting script 34
sign-off document 102
slave units 37
soft box 37, 52
Sosensky, Steven 45
special processing 26
specialty shots 35
studio lighting 52
studio sessions 11, 38, 46, 52
strobes 40, 46, 52
support personnel 15, 23
 hair stylists 15
 clothing stylists 15
 make-up artists 15

t
35mm cameras 37, 41
three quarter length shots 11, 35
trade shows 14-15
tripods 37, 41
turnaround times 23

u
umbrellas 37, 52

v
Versace, Vincent 41, 45

w
waivers of liability 20, 28
wardrobe 15, 23, 41

Other Books from Amherst Media, Inc.

Basic 35mm Photo Guide
Craig Alesse

Great for beginning photographers! Designed to teach 35mm basics step-by-step — completely illustrated. Features the latest cameras. Includes: 35mm automatic, semi-automatic cameras, camera handling, *f*-stops, shutter speeds, and more! $12.95 list, 9x8, 112p, 178 photos, order no. 1051.

Infrared Photography Handbook
Laurie White

Covers b&w infrared photography: focus, lenses, film loading, film speed rating, heat sensitivity, batch testing, paper stocks, and filters. Photos illustrate IR film in portrait, landscape, and architectural photography. $29.95 list, 8½x11, 104p, 50 b&w photos, charts & diagrams, order no. 1419.

Build Your Own Home Darkroom
Lista Duren & Will McDonald

This classic book teaches you how to build a high quality, inexpensive darkroom in your basement, spare room, or almost anywhere. Includes valuable information on: darkroom design, woodworking, tools, and more! $17.95 list, 8½x11, 160p, order no. 1092.

Into Your Darkroom Step-by-Step
Dennis P. Curtin

This is the ideal beginning darkroom guide. Easy to follow and fully illustrated each step of the way. Includes information on: the equipment you'll need, set-up, making proof sheets and much more! $17.95 list, 8½x11, 90p, hundreds of photos, order no. 1093.

Wedding Photographer's Handbook
Robert and Sheila Hurth

A complete step-by-step guide to succeeding in the world of wedding photography. Packed with shooting tips, equipment lists, must-get photo lists, business strategies, and much more! $24.95 list, 8½x11, 176p, index, b&w and color photos, diagrams, order no. 1485.

Lighting for People Photography
Stephen Crain

The complete guide to lighting. Includes: set-ups, equipment information, strobe and natural lighting, and much more! Features diagrams, illustrations, and exercises for practicing the techniques discussed in each chapter. $29.95 list, 8½x11, 112p, b&w and color photos, glossary, index, order no. 1296.

Camera Maintenance & Repair Book 1
Thomas Tomosy

A step-by-step, illustrated guide by a master camera repair technician. Includes: testing camera functions, general maintenance, basic tools needed and where to get them, basic repairs for accessories, camera electronics, plus "quick tips" for maintenance and more! $29.95 list, 8½x11, 176p, order no. 1158.

Camera Maintenance & Repair Book 2
Thomas Tomosy

Build on the basics covered Book 1, with advanced techniques. Includes: mechanical and electronic SLRs, zoom lenses, medium format cameras, and more. Features models not included in the Book 1. $29.95 list, 8½x11, 176p, 150+ photos, charts, tables, appendices, index, glossary, order no. 1558.

Restoring the Great Collectible Cameras (1945-70)
Thomas Tomosy

More step-by-step instruction on how to repair collectible cameras. Covers postwar models (1945-70). Hundreds of illustrations show disassembly and repair. $29.95 list, 8½x11, 128p, 200+ photos, index, order no. 1560.

Big Bucks Selling Your Photography
Cliff Hollenbeck

A complete photo business package. Includes secrets for starting up, getting paid the right price, and creating successful portfolios! Features setting financial, marketing and creative goals. Organize your business planning, bookkeeping, and taxes. $15.95 list, 6x9, 336p, order no. 1177.

Outdoor and Location Portrait Photography
Jeff Smith

Learn how to work with natural light, select locations, and make clients look their best. Step-by-step discussions and helpful illustrations teach you the techniques you need to shoot outdoor portraits like a pro! $29.95 list, 8½x11, 128p, b&w and color photos, index, order no. 1632.

Make Money with Your Camera
David Arndt

Learn everything you need to know in order to make money in photography! David Arndt shows how to take highly marketable pictures, then promote, price and sell them. Includes all major fields of photography. $29.95 list, 8½x11, 120p, 100 b&w photos, index, order no. 1639.

Leica Camera Repair Handbook
Thomas Tomosy

A detailed technical manual for repairing Leica cameras. Each model is discussed individually with step-by-step instructions. Exhaustive photographic illustration ensures that every step of the process is easy to follow. $39.95 list, 8½x11, 128p, 130 b&w photos, appendix, order no. 1641.

Guide to International Photographic Competitions
Dr. Charles Benton

Removes the mystery from international competitions and get all the information you need to select competitions, enter your work, and use your results for continued improvement and further success! $29.95 list, 8½x11, 120p, b&w photos, index, appendices, order no. 1642.

Freelance Photographer's Handbook
Cliff & Nancy Hollenbeck

Whether you want to be a freelance photographer or are looking for tips to improve your current freelance business, this volume is packed with ideas for creating and maintaining a successful freelance business. $29.95 list, 8½x11, 107p, 100 b&w and color photos, index, glossary, order no. 1633.

Infrared Landscape Photography
Todd Damiano

Landscapes shot with infrared can become breathtaking and ghostly images. The author analyzes over fifty of his most compelling photographs to teach you the techniques you need to capture landscapes with infrared. $29.95 list, 8½x11, 120p, b&w photos, index, order no. 1636.

Wedding Photography:
Creative Techniques for Lighting and Posing
Rick Ferro

Creative techniques for lighting and posing wedding portraits that will set your work apart from the competition. Covers every phase of wedding photography. $29.95 list, 8½x11, 128p, b&w and color photos, index, order no. 1649.

Professional Secrets of Advertising Photography
Paul Markow

No-nonsense information for those interested in the business of advertising photography. Includes: how to catch the attention of art directors, make the best bid, and produce the high-quality images your clients demand. $29.95 list, 8½x11, 128p, 80 photos, index, order no. 1638.

Lighting Techniques for Photographers
Norm Kerr

This book teaches you to predict the effects of light in the final image. It covers the interplay of light qualities, as well as color compensation and manipulation of light and shadow. $29.95 list, 8½x11, 120p, 150+ color and b&w photos, index, order no. 1564.

Photographer's Guide to Polaroid Transfer
Christopher Grey

Step-by-step instructions make it easy to master Polaroid transfer and emulsion lift-off techniques and add new dimensions to your photographic imaging. Fully illustrated every step of the way to ensure good results the very first time! $29.95 list, 8½x11, 128p, order no. 1653.

Infrared Nude Photography

Joseph Paduano

A stunning collection of images with how-to text that teaches how to shoot the infrared nude. Shot on location in natural settings, including the Grand Canyon, Bryce Canyon and the New Jersey Shore. $29.95 list, 8½x11, 96p, over 50 photos, order no. 1080.

How to Shoot and Sell Sports Photography

David Arndt

A step-by-step guide for amateur photographers, photojournalism students and journalists seeking to develop the skills and knowledge necessary for success in the demanding field of sports photography. $29.95 list, 8½x11, 120p, 111 photos, index, order no. 1631.

How to Operate a Successful Photo Portrait Studio

John Giolas

Combines photographic techniques with practical business information to create a complete guide book for anyone interested in developing a portrait photography business (or improving an existing business). $29.95 list, 8½x11, 120p, 120 photos, index, order no. 1579.

Fashion Model Photography

Billy Pegram

For the photographer interested in shooting commercial model assignments, or working with models to create portfolios. Includes techniques for dramatic composition, posing, selection of clothing, and more! $29.95 list, 8½x11, 120p, 58 photos, index, order no. 1640.

Computer Photography Handbook

Rob Sheppard

Learn to make the most of your photographs using computer technology! From creating images with digital cameras, to scanning prints and negatives, to manipulating images, you'll learn all the basics of digital imaging. $29.95 list, 8½x11, 128p, 150+ photos, index, order no. 1560.

Achieving the Ultimate Image

Ernst Wildi

Ernst Wildi teaches the techniques required to take world class, technically flawless photos. Features: exposure, metering, the Zone System, composition, evaluating an image, and more! $29.95 list, 8½x11, 128p, 120 b&w and color photos, index, order no. 1628.

Black & White Portrait Photography

Helen Boursier

Make money with b&w portrait photography. Learn from top b&w shooters! Studio and location techniques, with tips on preparing your subjects, selecting settings and wardrobe, lab techniques, and more! $29.95 list, 8½x11, 128p, 130+ photos, index, order no. 1626

Black & White Model Photography

Bill Lemon

Create dramatic sensual images of nude and lingerie models. Explore lighting, setting, equipment use, posing and composition with the author's discussion of 60 unique images. $29.95 list, 8½x11, 128p, 60 b&w photos and illustrations, index, order no. 1577.

The Beginner's Guide to Pinhole Photography

Jim Shull

Take pictures with a camera you make from stuff you have around the house. Develop and print the results at home! Pinhole photography is fun, inexpensive, educational and challenging. $17.95 list, 8½x11, 80p, 55 photos, charts & diagrams, order no. 1578.

Stock Photography

Ulrike Welsh

This book provides an inside look at the business of stock photography. Explore photographic techniques and business methods that will lead to success shooting stock photos — creating both excellent images and business opportunities. $29.95 list, 8½x11, 120p, 58 photos, index, order no. 1634.

Profitable Portrait Photography

Roger Berg

A step-by-step guide to making money in portrait photography. Combines information on portrait photography with detailed business plans to form a comprehensive manual for starting or improving your business. $29.95 list, 8½x11, 104p, 100 photos, index, order no. 1570

Professional Secrets for Photographing Children

Douglas Allen Box

Covers every aspect of photographing children on location and in the studio. Prepare children and parents for the shoot, select the right clothes capture a child's personality, and shoot story book themes. $29.95 list, 8½x11, 128p, 74 photos, index, order no. 1635.

Telephoto Lens Photography

Rob Sheppard

A complete guide for telephoto lenses! Shows you how to take great wildlife photos, portraits, sports and action shots, travel pics, and much more! Features over 100 photographic examples. $17.95 list, 8½x11, 112p, b&w and color photos, index, glossary, appendices, order no. 1606.

Restoring Classic & Collectible Cameras (Pre-1945)

Thomas Tomosy

Step-by-step instructions show how to restore a classic or vintage camera. Repair mechanical and cosmetic elements to restore your valuable collectibles. $34.95 list, 8½x11, 128p, b&w photos and illus., glossary, index, order no. 1613.

Handcoloring Photographs Step-by-Step

Sandra Laird & Carey Chambers

Learn to handcolor photographs step-by-step with the new standard in handcoloring reference books. Covers a variety of coloring media and techniques with plenty of colorful photographic examples. $29.95 list, 8½x11, 112p, 100+ color and b&w photos, order no. 1543.

Special Effects Photography Handbook

Elinor Stecker Orel

Create magic on film with special effects! Little or no additional equipment required, use things you probably have around the house. Step-by-step instructions guide you through each effect. $29.95 list, 8½x11, 112p, 80+ color and b&w photos, index, glossary, order no. 1614.

McBroom's Camera Bluebook

Mike McBroom

Comprehensive and fully illustrated, with price information on: 35mm, medium & large format cameras, exposure meters, strobes and accessories. Pricing info based on equipment condition. A must for any camera buyer, dealer, or collector! $29.95 list, 8½x11, 224p, 75+ photos, order no. 1263.

Swimsuit Model Photography

Cliff Hollenbeck

The complete guide to the business of swimsuit model photography. Includes: finding and working with models, selecting equipment, posing, using props and backgrounds, and more! $29.95 list, 8½x11, 112p, over 100 b&w and color photos, index, order no. 1605.

Glamour Nude Photography, *revised*

Robert and Sheila Hurth

Create stunning nude images! The Hurths guide you through selecting models, choosing locations, lighting, and shooting techniques. Includes: posing, equipment, makeup and hair styles, and more! $29.95 list, 8½x11, 128p, over 100 b&w and color photos, index, order no. 1499.

Fine Art Portrait Photography

Oscar Lozoya

The author examines a selection of his best photographs, and provides detailed technical information about how he created each. Lighting diagrams accompany each photograph. $29.95 list, 8½x11, 128p, 58 photos, index, order no. 1630.

Black & White Nude Photography

Stan Trampe

This book teaches the essentials for beginning fine art nude photography. Includes info on finding your first model, selecting equipment, and scenarios of a typical shoot, plus more! Includes 60 photos taken with b&w and infrared films. $24.95 list, 8½x11, 112p, index, order no. 1592.

Family Portrait Photography

Helen Boursier

Learn from professionals how to operate a successful portrait studio. Includes: marketing family portraits, advertising, working with clients, posing, lighting, and selection of equipment. Includes images from a variety of top portrait shooters. $29.95 list, 8½x11, 120p, 123 photos, index, order no. 1629.

The Art of Infrared Photography, *4th Edition*

Joe Paduano

A practical guide to the art of infrared photography. Tells what to expect and how to control results. Includes: anticipating effects, color infrared, digital infrared, using filters, focusing, developing, printing, handcoloring, toning, and more! $29.95 list, 8½x11, 112p, order no. 1052

Camcorder Tricks and Special Effects, *revised*

Michael Stavros

Kids and adults can create home videos and mini-masterpieces that audiences will love! Use materials from around the house to simulate an inferno, make subjects transform, create exotic locations, and more. Works with any camcorder. $17.95 list, 8½x11, 80p, order no. 1482.

The Art of Portrait Photography

Michael Grecco

Michael Grecco reveals the secrets behind his dramatic portraits which have appeared in magazines such as *Rolling Stone* and *Entertainment Weekly*. Includes: lighting, posing, creative development, and more! $29.95 list, 8½x11, 128p, order no. 1651.

Essential Skills for Nature Photography

Cub Kahn

Learn all the skills you need to capture landscapes, animals, flowers and the entire natural world on film. Includes: selecting equipment, choosing locations, evaluating compositions, filters, and much more! $29.95 list, 8½x11, 128p, order no. 1652.

Amherst Media's Customer Registration Form

Please fill out this sheet and send or fax to receive free information about future publications from Amherst Media.

Customer Information

Date

Name

Street or Box #

City State

Zip Code

Phone () Fax ()

Optional Information

I bought *The Photographer's Guide to Shooting Model & Actor Portfolios* **because**

I found these chapters to be most useful

I purchased the book from

City State

I would like to see more books about

I purchase _____ books per year

Additional comments

cut along dotted line ☛

FAX to: 1-800-622-3298

Name_____

Address_____

City_____State_____

Zip_____ — _____

Place
Postage
Here

Amherst Media, Inc.
PO Box 586
Buffalo, NY 14226